IMAGES
of America

SANTA'S VILLAGE

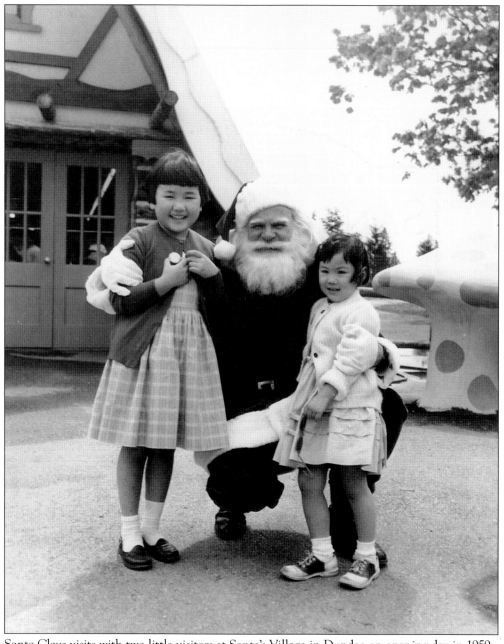

Santa Claus visits with two little visitors at Santa's Village in Dundee on opening day in 1959.

On the cover: The magic of the frozen North Pole and Santa Claus delight young visitors on a summer day in 1963. (Author's collection.)

IMAGES
of America

SANTA'S VILLAGE

Phillip L. Wenz

ARCADIA
PUBLISHING

Published by Arcadia Publishing
Charleston SC, Chicago IL, Portsmouth NH, San Francisco CA

Printed in the United States of America

Library of Congress Catalog Card Number: 2007925452

For all general information contact Arcadia Publishing at:
Telephone 843-853-2070
Fax 843-853-0044
E-mail sales@arcadiapublishing.com
For customer service and orders:
Toll-Free 1-888-313-2665

Visit us on the Internet at www.arcadiapublishing.com

In memory of Philip Oestreich

CONTENTS

ACKNOWLEDGMENTS

For nearly five decades, Santa's Village had been a part of the landscape of the Northern Fox River Valley region in Dundee. The park's success was not made up of buildings or attractions; it was made up of people. Whether it was the guests that traversed through the gate, the employee that operated a ride, or the creative ownership, people were the spirit that held all the other elements together. This book is dedicated to them.

I am very grateful to all those who have helped me throughout my career at Santa's Village. From the early morning coffee with the maintenance department to the wonderful helpers that worked in Santa's House and all those in between. I owe them a debt of gratitude. Special thanks to the North Pole Corporation management and office staff. To my parents Paul and Margaret Wenz who gave me their love of Christmas, and to my brothers Paul and Preston. A very appreciative thank-you goes to my Mrs. Santa Claus, DeAnn, and to my daughter, Holly, who appeared with me in many commercials.

Special acknowledgements to the public relations department and management of Santa's Village Dundee throughout the years, including Dorothy Strong, Ray Van Royce, Jack Morningstar, Donald Holliman, Tom Ratcliff, Jill Gewetzki, and Grant Dahlke. In the 46 seasons that the park was open, over 10,000 images were taken. Also thank you to Crystal Varney, Mark Schlueter, Matt Hohe, DeAnn Johnson, Sue Holliman, and Sue Leonard for the use of their photographs.

I would be remiss if I failed to thank all who encouraged the writing of this book, especially Gary Kellermann, Tom Pool, and Hugh Wilson. And a special thank-you to Butch and Darla Kuester, Mick Kuester, Stan Martin and the rest of the gang at the 103 East in Buckley, for letting me use the upstairs loft to lay out the thousands of images of Santa's Village.

—Phillip L. Wenz

INTRODUCTION

My Dear Friends,

Santa's Village is now a part of our collective memories. The recent efforts to save the park have come to an end. All parties made a gallant attempt. At this time Santa's Village is closed not knowing when or if the park will ever open again.

On Memorial Day, May 30, 1959, Mrs. Claus and I made Santa's Village in East Dundee our official home. The park was the third such village built by Glenn Holland of Crestline, California. Skyforest, California, was the first in 1955 (closed 1998) and Scotts Valley, California, in 1957 (closed 1979) was the second. For the first few years, our village in East Dundee was open 364 days a year. Over time, the season was shortened to the more commonly known schedule.

A lot has changed in the years since Santa's Village first opened. The Polar Dome Ice Arena, completed in February 1963, added a new state-of-the-art ice rink to the property. The dome had a huge, inflatable roof that was, at the time, the largest in the world. However, a storm came through the area in 1966 and tore the space age material. A year later, a flat roof was added.

Attractions of Santa's Village have come and gone. Some of you might remember the Christmas Tree Ride, the Pony Carts, and the Candy Cane Sleigh. How about the Pumpkin Coach or the Swiss Toboggan? Some of the attractions have endured over time, such as Santa's House, the Snowball Ride and of course the landmark of the park—the frozen North Pole.

You might have worked at the village over the years. Ride operators, shop workers, and food service hosts have added to the park's history. In the early days, pixies and elves helped our little visitors. Later our helpers wore brightly colored shirts and shorts. It is amazing that more than 11,000 teenagers and adults have worked at Santa's Village.

Santa's Village has welcomed over 20 million guests. Children of all ages have been entertained and memories have been made. Folks who visited the park in 1959 have brought their children, grandchildren, and even some great-grandchildren through our doors. On behalf of past and current employees, management, and owners, thanks to all of you who have made Santa's Village a childhood icon. We bid you a fond farewell and goodbye. And to all those who will keep Santa's Village in your hearts forever—remember, "Leave your cares behind and let them fade away; Santa's Village will always be just a dream away!"

With Warmest Regards to Children of all ages,

Santa Claus

One

ONE MAN'S DREAM

Santa's Village was born from a man who, as a child, had no real Christmas. Glenn Holland grew up in California during the Great Depression. His parents died by the time he was 18 years old, leaving him to care for his younger sister. As a grown man, Holland married and had children. As a father he tried to give his own children the type of Christmas that he only knew in his dreams.

In 1953, struck with inspiration, Holland sat at his kitchen table and started to sketch his idea of a Christmas fairyland where all the magic of the holiday would come to life. Holland developed this idea into a working plan and began finding investors for his project. He traveled the country selling his "Santa's Village" concept and eventually listed his new company, Santa's Village Corporation, on the California Stock Exchange.

The first Santa's Village opened in 1955, six weeks before Disneyland, in Skyforest near Lake Arrowhead in San Bernardino County, California. It remained open until 1998. A second Santa's Village opened in 1957 near Scotts Valley in Santa Cruz County, California. It remained open until 1979.

With the success of the first and second Santa's Villages, Holland began scouting a third location in the Midwest. The Chicago area, home to two world's fairs, birthplace of the Ferris wheel, and a center of entertainment and culture was picked as the spot. A suburban location approximately 45 miles northwest of the city was chosen.

Dundee was a tiny town with some local attractions and a few good restaurants. The community was surrounded by cornfields and a huge forest wildlife foundation area. The newly completed Northwest Tollway connected the small suburb to Chicago from the east and to Rockford from the west.

Holland had found the perfect location for his third Santa's Village.

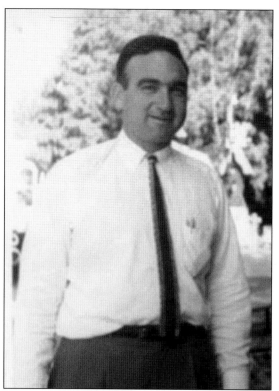

Glenn Holland was the creative force behind Santa's Village, the world's first theme park chain. Holland was inspired to create a Santa Claus–type fantasyland through his lack of Christmas celebrations as a child and by Santa Claus Town, which was officially launched in 1935, in Santa Claus, Indiana. Years before Disney, Santa Claus Town served as a strong influence for other Santa Claus–themed attractions that would later appear throughout the United States.

The original Santa's Village opened on Memorial Day in 1955 in Skyforest, California. It cost about $1 million to build and was constructed in less than a year by Henck Construction.

10

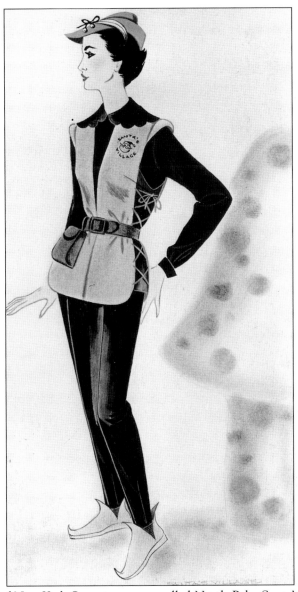

In the upper part of New York State in a town called North Pole, Santa's Workshop opened in 1949. Santa's Workshop was featured in a *Saturday Evening Post* article that caught the attention of Glenn Holland. Holland sat at his kitchen table and designed his version of a Christmas-themed village that would become the home of Santa Claus. By 1953, Holland and his new associate, Leonard O. Ray, were ready to find a location to build their version of the Santa Claus–theme idea. They approached Joseph Henck to see if he would lease some of the acreage his family owned to build Santa's Village. Henck agreed and became part of the new Santa's Village Corporation. In the Articles of Incorporation, dated July 14, 1954, it stated that the business would "engage generally in the construction and operation of villages depicting the home and workshops of Santa Claus, to equip and supply inventory for said villages, to provide exhibits, displays, toys, animals, and appurtenances consistent with the Santa Claus legend." It was signed by Holland of Crestline, California; Henck of Skyforest, California; and Ray of Crestline, California.

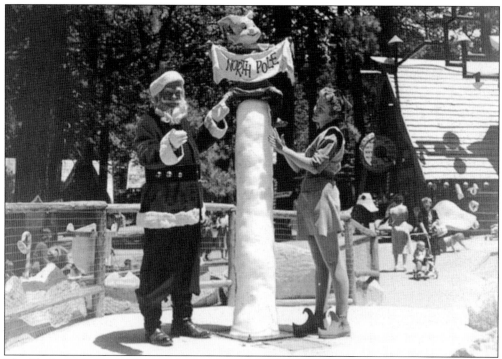

The Skyforest Santa's Village was a big success even though less than 50 days after its opening Walt Disney's Disneyland opened in nearby Anaheim, California.

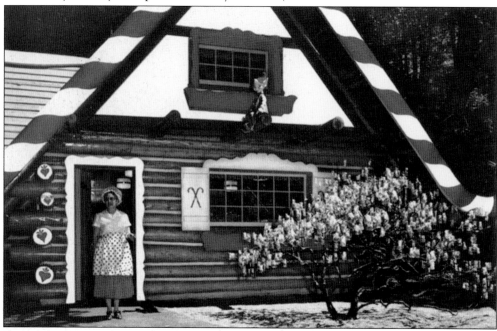

Part of the success of Santa's Village was the creativeness of Glenn Holland to take the public domain figure of the Santa Claus legend and make it a merchandisable commodity. Santa's Village Corporation developed their own brands of candies, jellies, and spices that could be bought in the village at Mrs. Claus's Candy Kitchen or through mail order.

The park was laid out in a beautiful evergreen surrounding. Children and adults alike enjoyed the whimsical buildings and attractions.

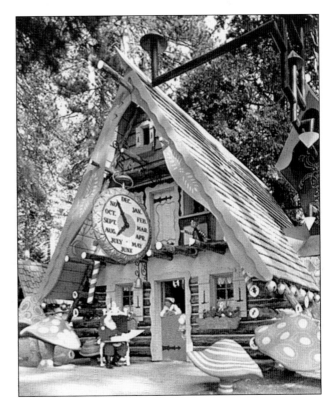

Santa's House featured not only the good saint himself, but his Good Book, sleigh bed, and a huge stone fireplace.

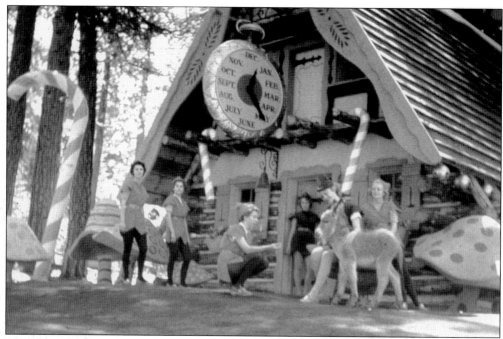

The pixie costume was chosen for the general employees so that they would blend into the Santa Claus legend.

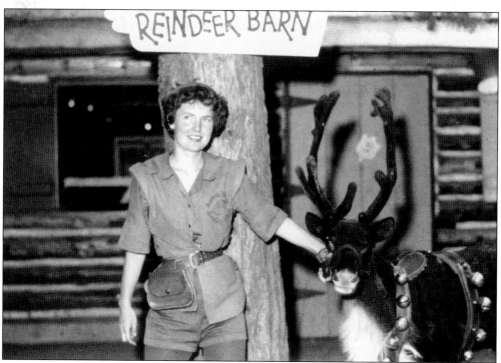

Animals, especially reindeer, were a very important part of Santa's Village. The smaller animals actually roamed free within the confines of the village. Children especially enjoyed feeding the roaming goats.

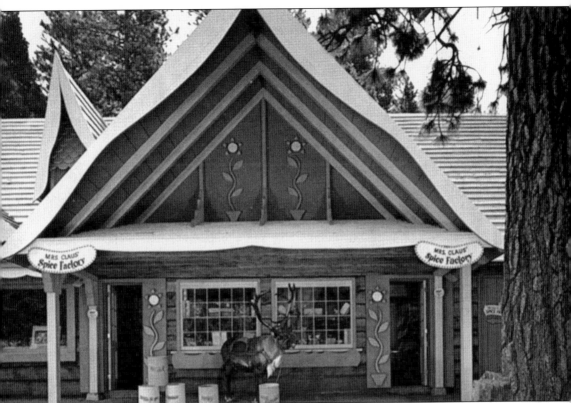

The village's unique-looking buildings were designed by architect Harry A. Seagondollar Jr. of Rialto, California. The buildings were very fanciful but authentic. The logs and lumber for the construction were cut right from the property.

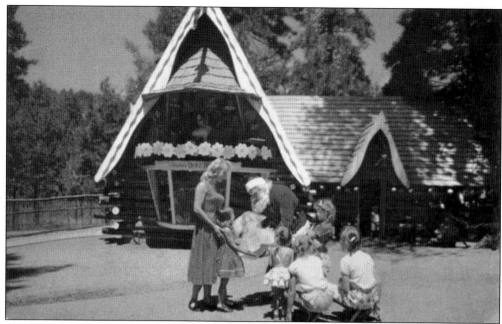

Attractions like the Doll House were designed with children in mind. The uniqueness of the retail stores helped sell the products.

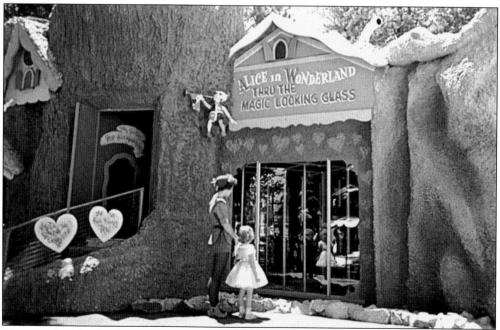

The use of public domain names and characters was imperative to Santa's Village. Without any licensing fees, costs could be kept down on the merchandise aspect of the business.

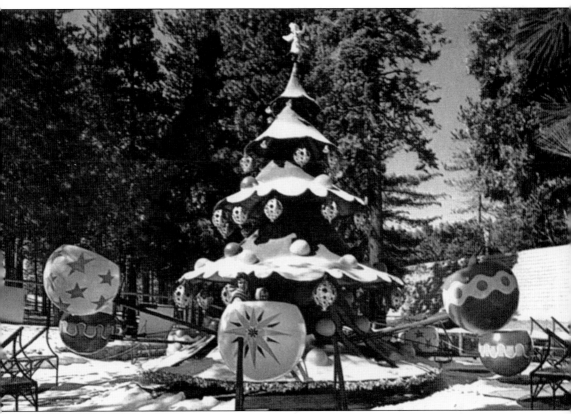

Two ride contractors named Burke Malcom and Warren Schafe were brought in to help devise the Christmas Tree Ride and the Magic Train Ride. Keeping the rides to theme was important to the experience of the village.

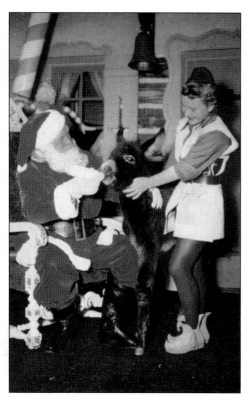

The casting of the role of Santa Claus was crucial to Santa's Village success. Santa had to act and look as if he had just stepped out of the pages of a child's storybook. Multiple Santas, a lead and two relief Santas, were needed as the village was going to be open 364 days a year.

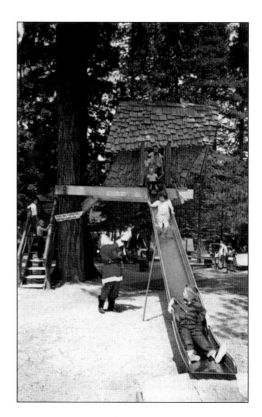

Even a simple tree house slide was themed. The belief in the Santa Clause myth was paramount.

To enhance the guest experience, other live characters were added to the village's interactive presentation, including Jack Pumpkin Head, Mr. Bunny, the Lollipop Lady, the Good Witch, and the Pumpkin Princess that rode with children in her pumpkin coach.

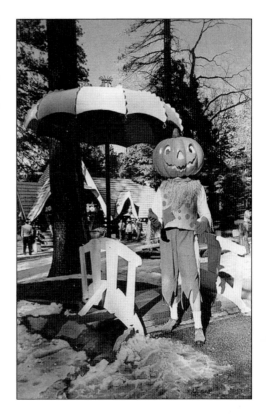

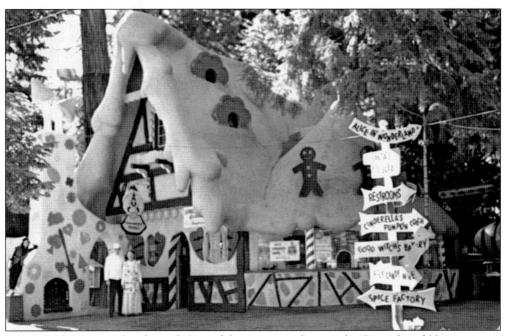

Eating facilities were also themed. One of the most popular was the Gingerbread House.

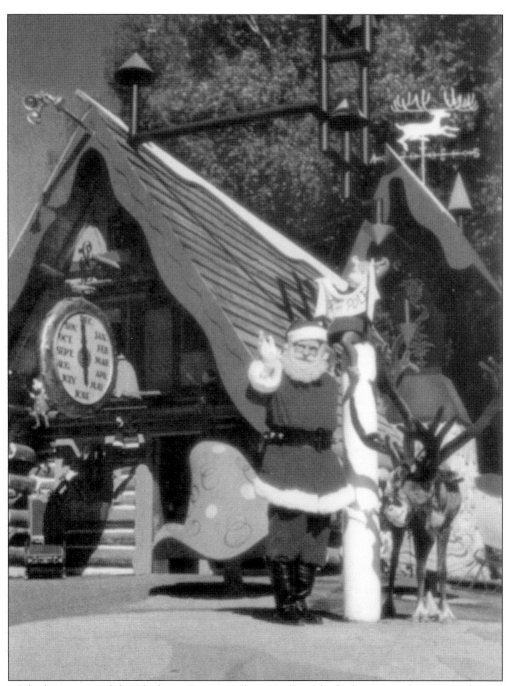

With the success of the Skyforest Santa's Village, Holland looked to expand and use what he had learned to build another Santa's Village in northern California. Ground was broken in August 1956 for the Scotts Valley Santa's Village in Santa Cruz County, California. The park was very similar to the Skyforest location, with a few exceptions. Like the first park, Santa's Village Scotts Valley opened on Memorial Day, 1957, to large crowds. Above is Santa's House in Scotts Valley.

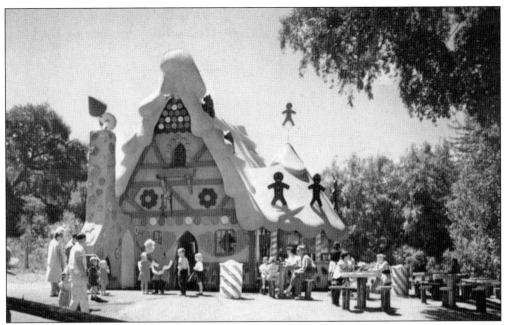

The buildings of the new Santa's Village in Scotts Valley looked very familiar to those of Skyforest. The Gingerbread House of Scotts Valley is seen above.

Come lose your heart in

Santa's Village

In an Evergreen Forest Setting

Glenn Holland had created a new segment of the theme park industry. Years before Six Flags started to create parks all over the country, Santa's Village Corporation had developed two successful parks in two years. Why not a third? The formula was there.

An ever-bright legend comes to life!

"Here, in a magic land of make-believe, the enchanting legend of Santa Claus comes true with startling realism."

The whimsy, fantasy and tenderness of the Santa Claus legend we remember as little tots is all here just as we imagined it would be—a world of delightful story-book folk who re-confirm our faith in a dream that somewhere real elves and gnomes work constantly to gladden all lives on Christmas morning; that there really IS a place where Santa spends the other 364 days of the year with Mrs. Claus, the Easter Bunny, Jack Pumpkinhead and other friends from Never-Never Land.

When you enter the Welcome House you'll walk back into your own childhood and

YOU'LL LOSE YOUR HEART!

TOY SOLDIER stands guard over the Mill Wheel Toy Factory, one of several fascinating shops.

SANTA'S HOME, where you'll find the Good Book with, perhaps, your name! Santa's unusual clock tells the time of the year.

Santa's Village Corporation looked to expand eastward. The massive Chicago market looked perfect. Glenn Holland sought a piece of property that was very similar to the other Santa's Villages. He found it in a tiny town called Dundee.

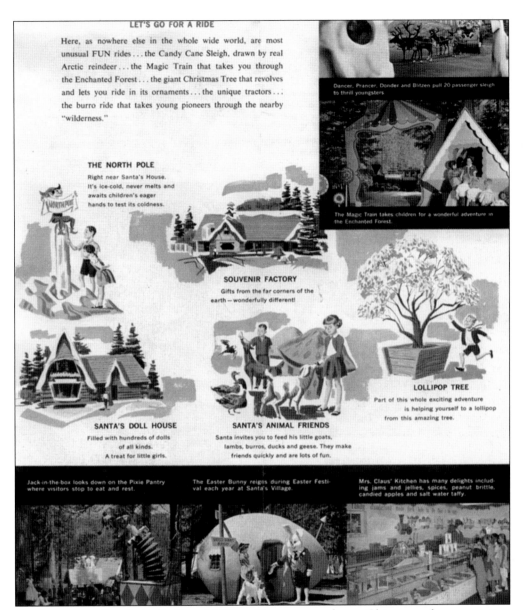

LET'S GO FOR A RIDE

Here, as nowhere else in the whole wide world, are most unusual FUN rides...the Candy Cane Sleigh, drawn by real Arctic reindeer...the Magic Train that takes you through the Enchanted Forest...the giant Christmas Tree that revolves and lets you ride in its ornaments...the unique tractors...the burro ride that takes young pioneers through the nearby "wilderness."

Dancer, Prancer, Donder and Blitzen pull 20 passenger sleigh to thrill youngsters

The Magic Train takes children for a wonderful adventure in the Enchanted Forest.

THE NORTH POLE

Right near Santa's House. It's ice-cold, never melts and awaits children's eager hands to test its coldness.

SOUVENIR FACTORY

Gifts from the far corners of the earth — wonderfully different!

LOLLIPOP TREE

Part of this whole exciting adventure is helping yourself to a lollipop from this amazing tree.

SANTA'S DOLL HOUSE

Filled with hundreds of dolls of all kinds. A treat for little girls.

SANTA'S ANIMAL FRIENDS

Santa invites you to feed his little goats, lambs, burros, ducks and geese. They make friends quickly and are lots of fun.

Jack-in-the-box looks down on the Pixie Pantry where visitors stop to eat and rest.

The Easter Bunny reigns during Easter Festival each year at Santa's Village.

Mrs. Claus' Kitchen has many delights including jams and jellies, spices, peanut brittle, candied apples and salt water taffy.

Dundee was a perfect choice for Santa's Village. The town was close to Chicago, and transportation to and from the location was good.

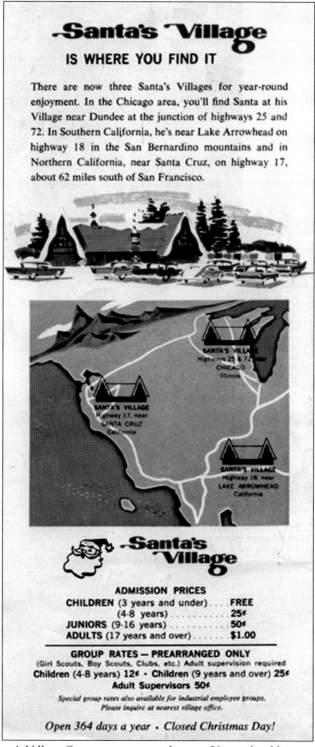

Santa's Village

IS WHERE YOU FIND IT

There are now three Santa's Villages for year-round enjoyment. In the Chicago area, you'll find Santa at his Village near Dundee at the junction of highways 25 and 72. In Southern California, he's near Lake Arrowhead on highway 18 in the San Bernardino mountains and in Northern California, near Santa Cruz, on highway 17, about 62 miles south of San Francisco.

ADMISSION PRICES
CHILDREN (3 years and under).... FREE
(4-8 years) 25¢
JUNIORS (9-16 years) 50¢
ADULTS (17 years and over)...... $1.00

GROUP RATES — PREARRANGED ONLY
(Girl Scouts, Boy Scouts, Clubs, etc.) Adult supervision required
Children (4-8 years) 12¢ · Children (9 years and over) 25¢
Adult Supervisors 50¢

*Special group rates also available for industrial employee groups.
Please inquire at nearest village office.*

Open 364 days a year · Closed Christmas Day!

In April 1958, Santa's Village Corporation entered into a 50-year land lease with Edwin Eichier of McGraw's Wildlife Foundation for the third Santa's Village.

Two

SANTA'S VILLAGE IN DUNDEE

In April 1958, Glenn Holland entered into a 50-year land lease on 40 wooded acres of McGraw's Wildlife Foundation with Chicago businessman Edwin Eichier. The property, located on State Routes 25 and 72, was similar to the settings of Holland's two California endeavors. In September, ground was broken, and the third Santa's Village was born.

Santa's Village Corporation and general contractor Putnam Henck built Santa's Village in Dundee in nine months at a cost of $1 million. The Dundee park officially opened on Memorial Day weekend in 1959 to large crowds. On hand to greet these visitors of all ages was Santa, Mrs. Claus, and numerous helpers dressed as pixies and elves. These pixies and elves operated rides, worked in shops, and served food to the public. Santa had a petting zoo with sheep, ducks, goats, and Penny Peck, the educated chicken. Children could ride a Mexican burro or in a sleigh pulled by real, live reindeer from Unalakeet, Alaska. Other rides included a giant whirling Christmas tree, gasoline-powered tractors, and the Tree House Slide. Children could see a puppet show at the Wee Puppet Theater, a giant jack-in-the-box, and brightly-colored mushrooms that dotted the landscape.

There was also Santa's Post Office, the Reindeer Barn, and a Gingerbread House. Mrs. Claus made fresh candy daily in her Candy Kitchen. The Pixie Pantry served hotdogs, hamburgers, fries, and sodas. Santa's Toy Factory was also there by the magic pond. Wishing wells, toy soldiers, and outdoor displays could be seen. Music flowed from treetop speakers. There was even an egg-shaped hut for the Easter Bunny.

As one looked around the village, one could see over a dozen log buildings, stores, and attractions. These buildings had pointed roofs strengthened by rafters. The log structures were brightly colored and had wonderful detail like gingerbread trim and surrealist features. They fit in with the beautiful trees that were part of the Fox Valley region.

Santa's Village in the first few seasons was open 364 days a year. The layout of the village stayed mainly the same until an extensive expansion program, which began in early 1962, started to change the makeup of the park.

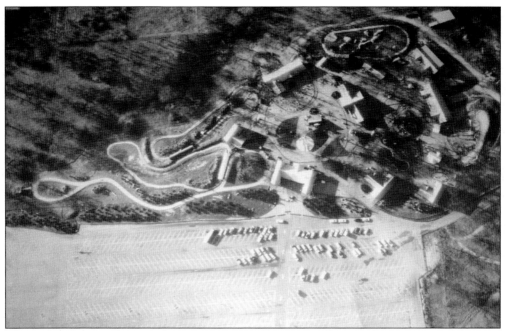

This aerial photograph shows the original layout of Santa's Village in Dundee in 1959. The large circle area on the picture is where the Polar Dome Ice Arena would be built. The park opened on Memorial Day weekend and stayed open for the next 46 years. Santa's Village originally featured seven rides, which included the Christmas Tree, Candy Cane Sleigh, Magic Train, Burro Ride, Pumpkin Coach, gasoline-powered tractors, and the Tree House Slide.

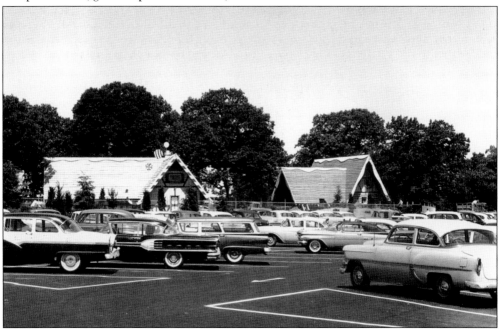

Parking was always free at Santa's Village. The parking lot had room for well over 1,300 cars. Notice the details of the large lollipops on the backside of Mrs. Claus's Candy Kitchen. All of the 13 original building had fine details.

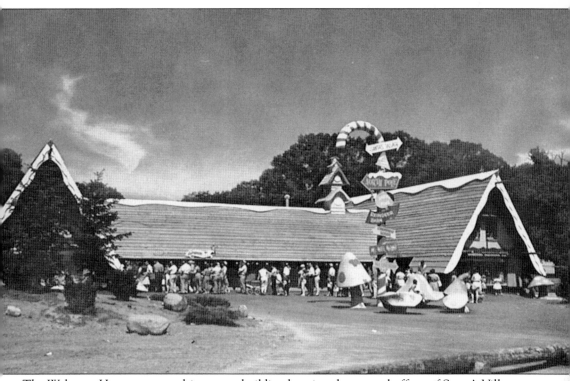

The Welcome House was a multi-purpose building housing the general offices of Santa's Village Corporation. Offices were located on the second floors of both ends of the building. The actual entrance into the park was in the south end of the building where in 1992, the Guest Services offices were built. The Exit Shop composes the middle and north end of the lower level. In the park, money never exchanged hands as a small passport ticket was used to keep track of the guest's expenses. The passport would be checked at the end of the visit in the exit shop.

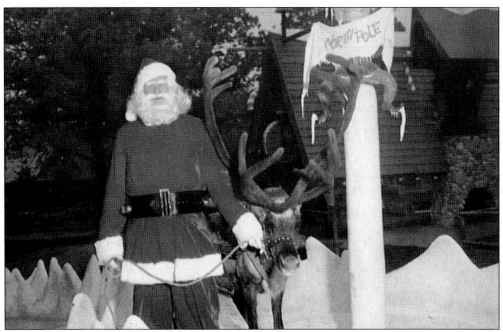

Santa Claus stands by the Frozen North Pole. The pole was in the center of the village in an area referred to as North Pole Plaza. Cement snow made a pathway to and from the Plaza.

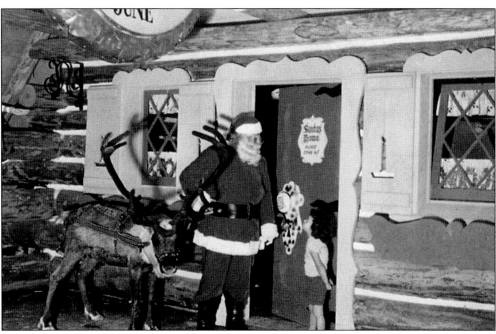

Santa's House was located near the center of the park. Here Santa meets up with one of his little friends. Notice the windows of the house are open. Santa's House was not air condition until 1963.

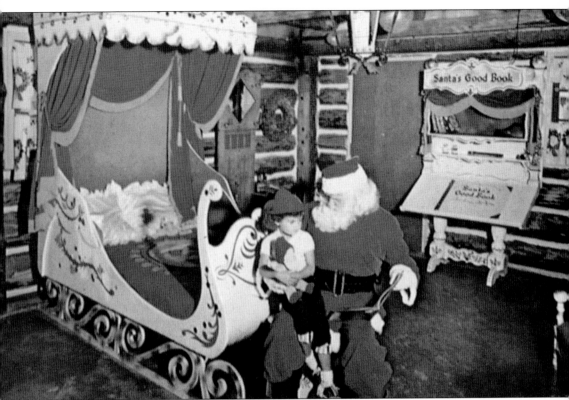

A child visits with Santa inside his house. Notice the sleigh bed and the Good Book desk. These two props, along with other originals, were used for 46 years. The sleigh bed was removed in 1990 and put in storage for safe keeping. Santa would often move his chair outdoors on nice days and visit children under a shady tree.

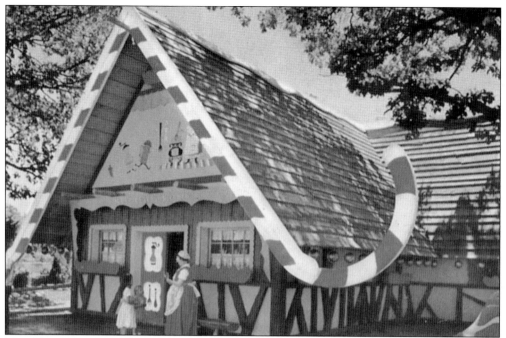

Mrs. Claus's Candy Kitchen was a candy shop that sold hand-dip chocolates and hard candies. Mrs. Claus was on hand each day to supervise.

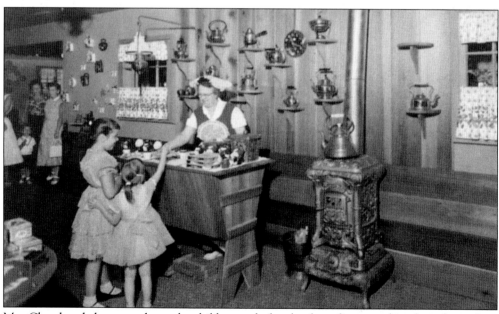

Mrs. Claus handed out samples to the children and often let them dip some chocolates themselves.

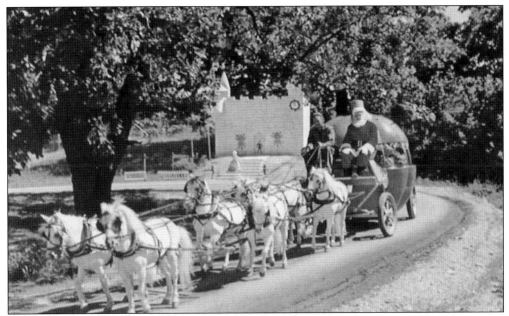

This is Cinderella's Pumpkin Coach; a life-size coach that guests could ride in, it was pulled by miniature white ponies. The turn around area contained a static display of Prince Charming's Castle.

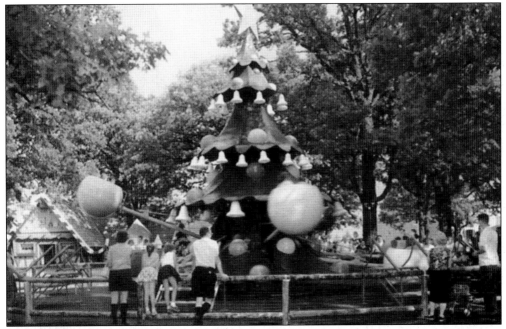

The Christmas Tree Ride was a giant whirling tree where guests could ride in a Christmas ornament that would go up and down with the pull of a lever. This ride was the marquee ride for all three Santa's Villages.

The Wee Puppet Theater produced daily hand and marionette puppet shows in an indoor theater. Later on, this building became a cartoon theater, a story time theater, and ended up as the Haufbrau House Restaurant.

The Good Witch and a small friend take a little break near the Magic Train in 1959.

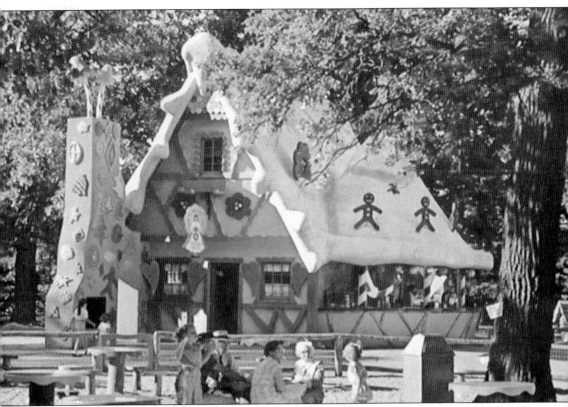

The Gingerbread House was an actual working bakery that featured gingerbread cookies and baked goods. Large windows allowed guests to watch as pixies made the sweet treats. The Gingerbread House was also home to the Good Witch and the Lollipop Lady. Right behind the outside fireplace, children could accompany the Lollipop Lady and pick a sucker from the lollipop tree.

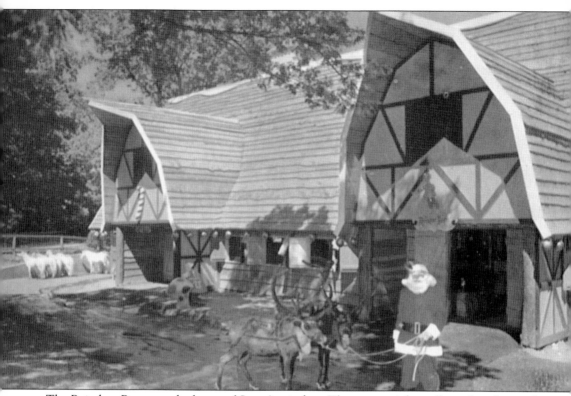

The Reindeer Barn was the home of Santa's reindeer. There were eight stalls, and at the north end of the barn Inky the reindeer, along with his friends Peck the chicken and Hunt the duck, printed the park's official newspaper, the *Pixie Press*.

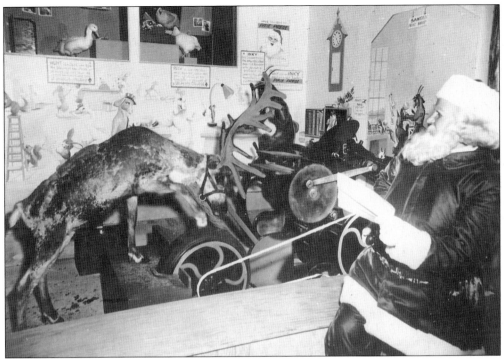

Here Santa Claus looks over a copy of the *Pixie Press*. Children could subscribe to the *Pixie Press* and have the latest issue mailed to them each month.

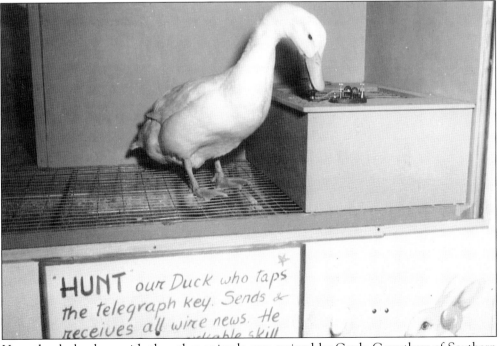

Hunt the duck, along with the other animals, was trained by Grady Corruthers of Southern California. Corruthers also developed the animal-driven rides for all three Santa's Villages. The Pumpkin Coach, Candy Cane Sleigh, and the burro rides were credited to him.

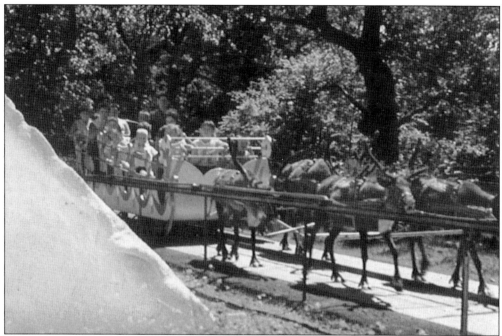

On the Candy Cane Sleigh, guests could ride in a sleigh pulled by Santa's reindeer. The journey took them through icecaps and the Elves Village in search of the Snow Queen.

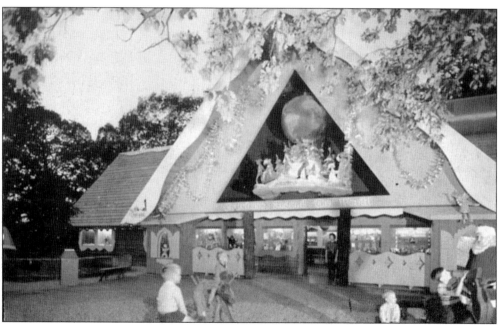

This is the Christmas Around the World Post Office, which was a large building that housed many exhibits and services such as an actual post office, letter writing to Santa, windows showing the celebrations of Christmas around the world, a souvenir counter, guest services, and restrooms. Offices were located on the second floor.

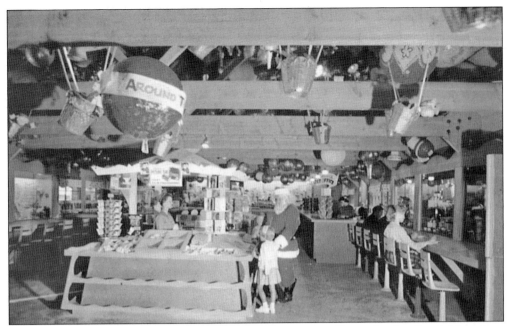

Inside the Christmas Around the World Post Office one could see the details of this unique attraction. The Dundee village was the only one of the three Santa's Villages to have this building. In later years, this building was remodeled. A complete second floor was added, the post office was removed, and an arcade was put in.

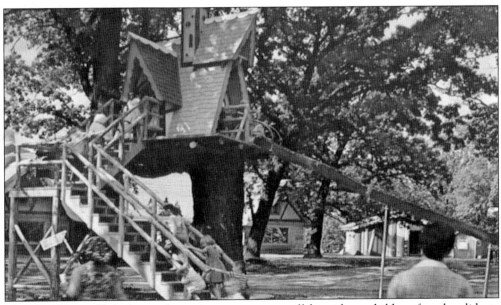

The Tree House Slide featured a staircase up to a small hut where children found a slide to come down. The slide ended in a sand box. This is the only attraction in the park's history that remained virtually unchanged and in its original location. Santa's House was relocated when the Polar Dome Ice Area was built.

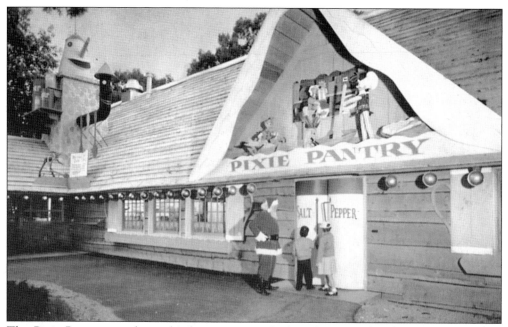

The Pixie Pantry was the park's largest eating facility that served cafeteria-style sit-down meals in the main section and hamburgers, hotdogs, and other typical fast food through a walk-up window.

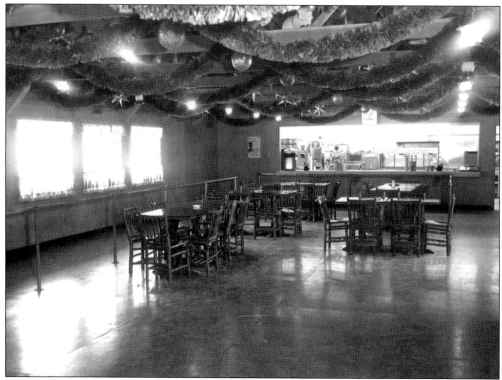

The inside of the Pixie Pantry was decorated with large flowing garlands, oversized ornaments, and wooden elves.

All of Santa's helpers wore pixie outfits during the early years at Santa's Village.

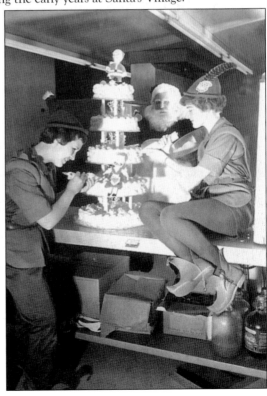

In this picture, two of Santa's helpers finish decorating one of the large cakes that were sold daily in the Pixie Pantry.

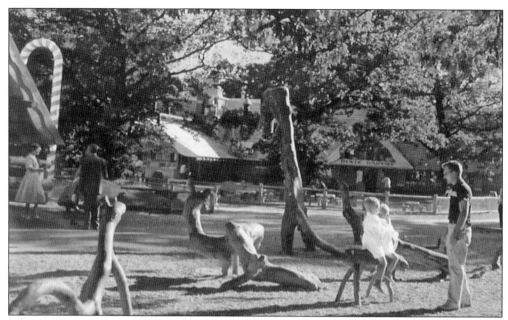

Behind Santa's House were large, wooden log sculptures that children could sit and climb on known as Woodanimals.

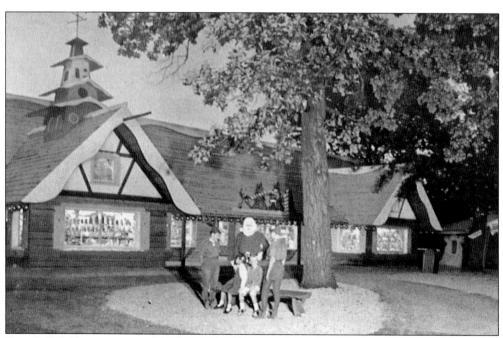

Santa's Gift Shop was one of the largest buildings in the park. The shop was divided into three sections, toys for children, gifts for mom and dad, and a Christmas shop.

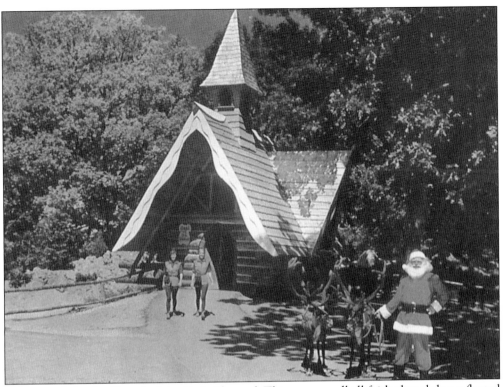

Santa stands by the Chapel of the Little Shepard. This was a small all-faith chapel that reflected on children's bible stories through small exhibits.

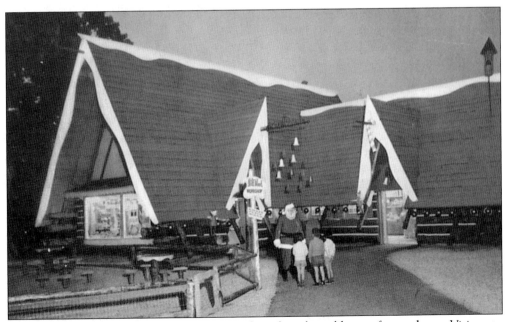

Santa's Millwheel Workshop was an artisan's shop that also sold manufactured toys. Visitors to the workshop saw hand-crafted toys and keepsakes being made.

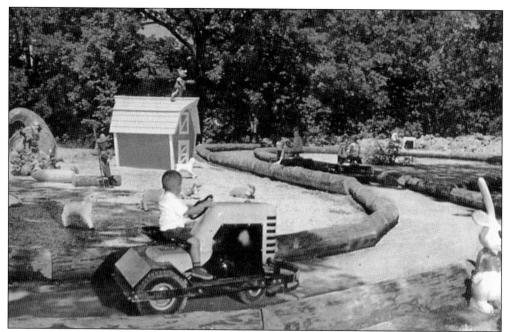

The gasoline-powered tractors were small tractors that children could drive around a small farm set-up. They were the first ride to be removed from the park in 1961.

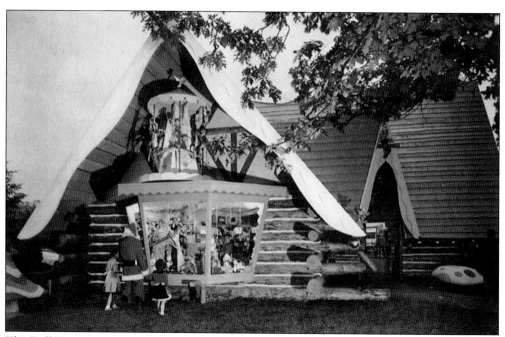

The Doll House was a shop that contained unique dolls and accessories from all over the world. It was a little girl's paradise.

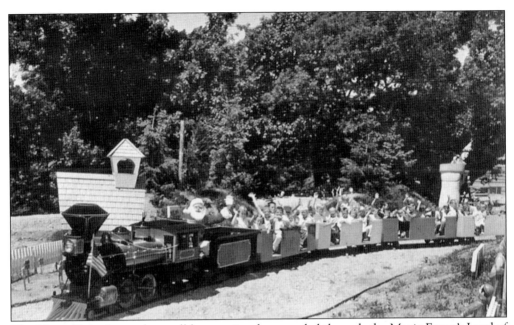

The Magic Train featured a small locomotive that traveled through the Magic Forest's Land of Enchantment. The layout had numerous static displays from nursery rhymes such as "The Old Woman who Lived in a Shoe" and "Little Boy Blue."

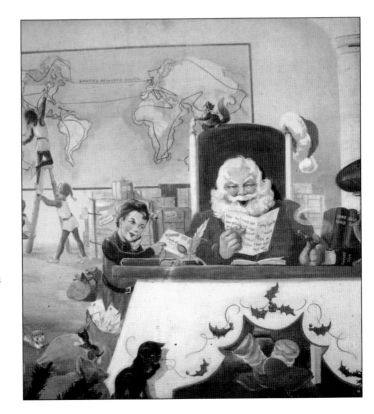

Inside the buildings of Santa's Village were wonderful paintings that were produced for the park by artists from northern California. This painting is one section of a four-section mural that was located in the Christmas Around the World Post Office. In the early 1990s, the painting was retouched and put in Santa's House.

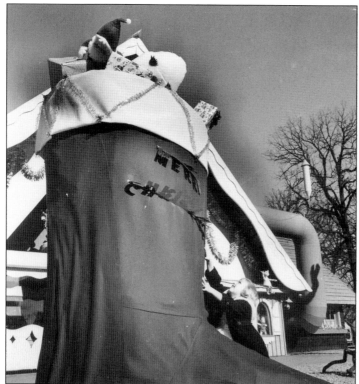

The world's largest Christmas stocking was a huge hit with the children at Santa's Village in the fall of 1959. Guests of the village could register their names to win the over-sized stocking for Christmas. The 10-foot sock held over 100 toys, games, and novelties.

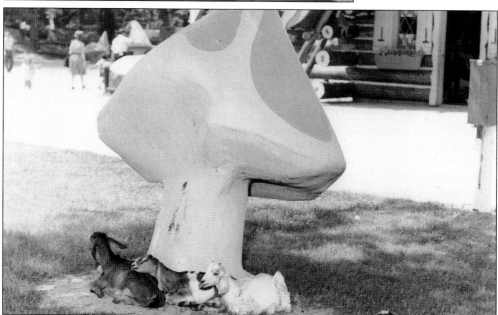

Park creator Glenn Holland wanted his visitors to have a complete experience, so he installed these brightly colored concrete toadstools and mushrooms all over the landscape. According to Norwegian legend, the Vindicans (little people), who were craftsmen, lived in the toadstools and mushrooms. Pixies and elves along with gnomes are a direct relative to the Vindican. Holland gave all of Santa's helpers a place to live in the village.

Three

MAJOR EXPANSION

Arrow Development of California was contracted by Santa's Village Corporation to develop some new attractions for the park. Arrow Development was best known as the company that built the Disneyland rides in Anaheim, California. The first major change at Santa's Village came in removal of the wishing well in the front of the park next to the Entrance House. Ground was broken in the spring of 1962 for the Dundee village's most enduring attraction—the Snowball Ride.

The expansion also included the redevelopment of the Magic Train, which was relocated deeper into the forest setting of Santa's Village. A brand new C. P. Huntington engine was added to the train along with an extension of the tracks. The new layout actually looped in and out of the parking lot. The Antique Cars were installed in the space vacated by the Magic Train.

The year 1962 also saw the start of the biggest development in the park's history, the Polar Dome Ice Arena. Part of the park's original layout had to be moved to make room for the 40,000-square-foot ice arena. The first relocation was that of North Pole Plaza and Santa's House. They were moved into an empty space near the newly added Snowball. Originally these two attractions sat near what became the center ice of the dome. They also relocated the Toy Soldier (Duck Pond) and the Jack-in-the-Box Snow Cone Stand. The Polar Dome project took a little more than a year to complete at the cost of $350,000; a very tidy sum in the early 1960s.

The dome opened in February 1963 to national reviews. The original Polar Dome Ice Arena design sat 4,000 people and was the largest air-supported dome stadium in the world according to the Guinness Book of World Records. Top name acts appeared in the dome such as the International Showtime Circus with Don Ameche, magician Mark Wilson's Magic Land of Allakazam, and the National Olympic Speed Skating Competition (videotaped for ABC's Wide World of Sports). Numerous ice-skating revues and hockey games, including Chicago Black Hawks exhibition games, as well as wrestling matches, concerts, and roller derby events filled out the entertainment.

Santa's Village was also a big hit in the movies. Between 1964 and 1966, three movie shorts were shot on location in the park by Florida-based producer K. Gordon Murray including 1964's *Santa Claus and his Helpers*, 1966's *Santa's Magic Kingdom*, and 1966's *Santa's Enchanted Village*. The shorts used the park's employees and characters in the cast, as well as some of the village's more noticeable props.

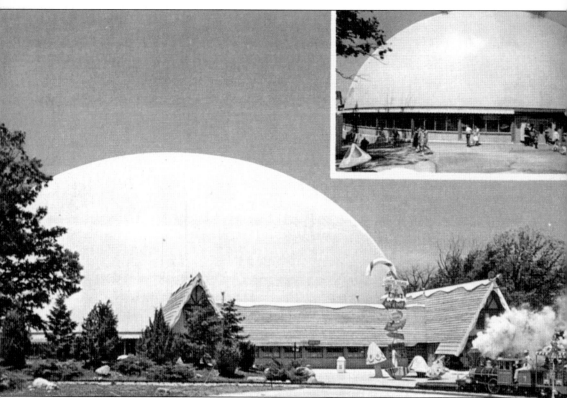

During the years 1962 through 1966, Santa's Village in Dundee experienced major growth in its attractions. The park had been successful during the first two years, but Santa's Village Corporation did not count on the harsh winter weather that was part of northeastern Illinois. Beginning in the spring of 1962, a major expansion was in the works. Known as the Polar Dome project, it included more than just the new space aged ice rink. New attractions were added prior to the groundbreaking of the dome. The project took a little more that a year to complete and added to the existing layout of the village and changed the course of Santa's Village in Dundee forever.

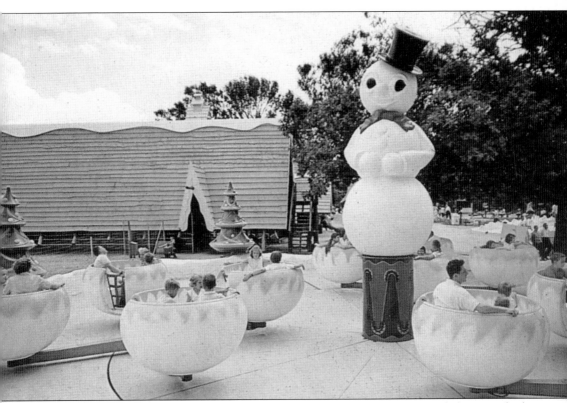

The spring of 1962 saw the addition of the most enduring ride that the park has ever had, the Snowball Ride. Built by Arrow Development of California, the ride was a basic teacup ride that was heavily themed to match the atmosphere of Santa's Village. The Dundee village, along with the Scotts Valley village, received Snowball rides. The Scotts Valley Snowball Ride was removed after the closing of that park and today is a ride at the Santa Cruz Boardwalk in northern California. The Dundee Snowball Ride was auctioned off in October 2006 and today sits at the Grand Bear Lodge Resort in Utica.

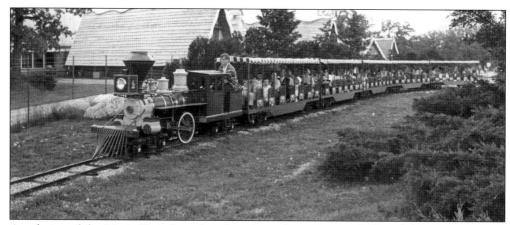

A redesign of the Magic Train brought a brand new larger engine and track layout to Dundee. A new C. P. Huntington engine and cars were added in 1962. The new train handled adult passengers along with children. The track was extended from the Pixie Pantry area out into the parking lot.

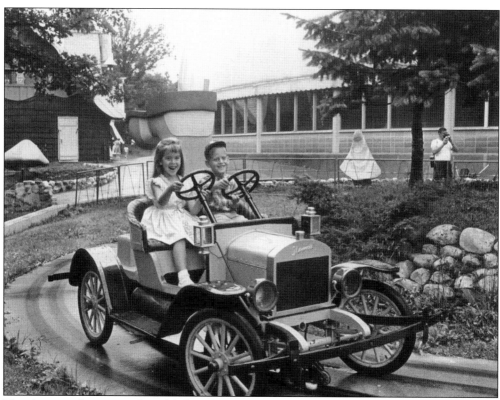

The Antique Cars were also added in the first phase of the expansion in 1962. The ride was located where part of the original train layout had been and utilized the small tunnel that was built in 1959 for the smaller locomotive engine of the Magic Train. This ride was also a product of Arrow Development.

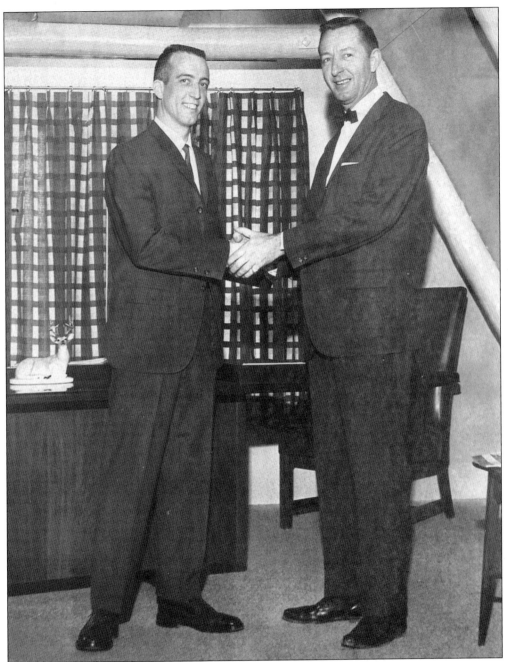

Former general manger Ray Van Royce (left) shakes hands with the new Santa's Village general manger Jack Morningstar. The 1960s brought a lot of change to the Dundee village's top management. Charles L. Poe, the original general manager, went back to the corporate offices in California and was replaced in 1962 by Van Royce, a native of Carpentersville. Van Royce oversaw the first and the start of the second phase of the expansion project that included the Polar Dome. Middletown, Ohio, native Jack Morningstar replaced Van Royce in 1963. Morningstar had great credentials with parks and attractions. He had been an exhibit manager at the world's fair in Seattle, Washington, and the general manger of LeSourdsville Park in Ohio.

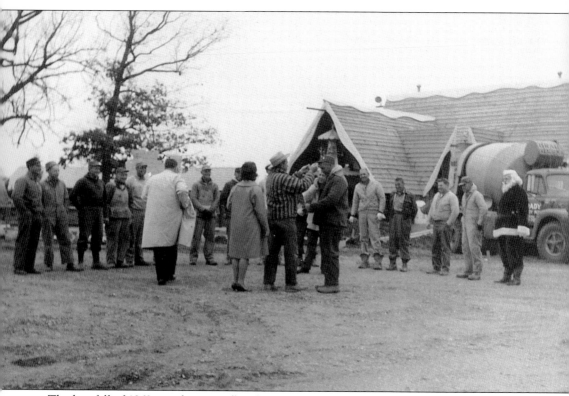

The late fall of 1962 saw the groundbreaking for the Polar Dome Ice Arena. The original dome became a masterpiece in modern architecture. The structure had 12 foot walls of glass, brick, and concrete, forming a complete circular base that was 665 feet around. Over 7,000 square yards of plastic nylon composed the roof, which was inflated to 87 feet. At the time, it was the largest commercial air supported structure ever built. With no supporting columns, beams, or arches, the only overhead structure was the three-ounce-per-square-foot fabric skin. Eight blowers, any two of which supported the shell, safeguarded against mechanical failure. A fully-automatic auxiliary electrical generating plant insured a continuous power supply at all times. Seating capacity of the original dome was 3,000 to 5,000 depending on the type of event scheduled. Maneuverable risers made it possible to change the location of the seats to fit the various events that were booked.

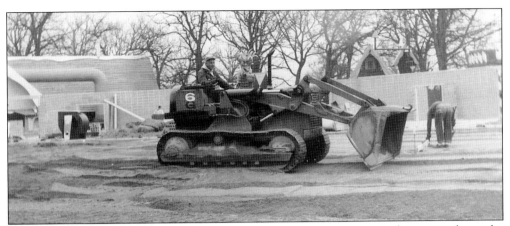

The building of the dome was a massive undertaking. Here a bulldozer works to smooth out the dirt floor during construction. The dome was 209 feet in diameter and housed an ice rink that was 185 by 85 feet, with some 15,725 square feet of ice surface. More than 47,000 feet of one-inch pipe was laid in the ice rink floor.

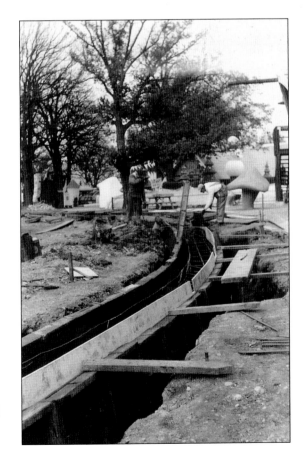

The original Polar Dome design stressed occupant safety as the first consideration. Due to the internal inflation pressure, the fabric of the shell would not support combustion, thus making it a fire-safe structure.

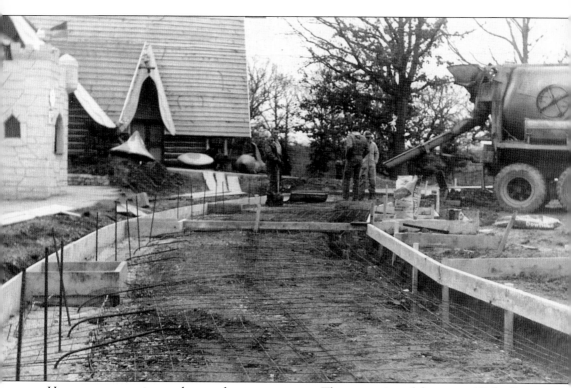

Here are construction workers ready to pour cement. The patterning of the original Polar Dome shell was precise to avoid stress concentrations in the lightweight skin. The elastic characteristics of the fabric at the design loads were taken into account so that the final dome would be smooth and uniformly loaded. Over 17,000 miles of yarn was spun from which nearly 7,000 yards of fabric was woven, scoured, processed, and coated with a special formula vinyl plastic.

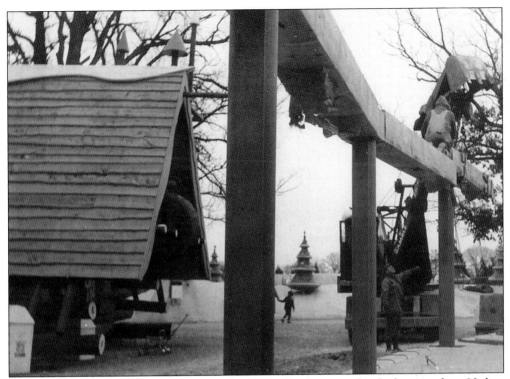

The building of the 40,000-square-foot Polar Dome Ice Arena took a little more than 90 days to complete. The project ran a little longer than the 60 days that was estimated by the chief engineer. Burke Malcolm had supervised the entire project. These delays caused the dome to open in February 1963 instead of December 1962 as originally planned. With the completion of the ice rink the Polar Dome project was finished in little over a year.

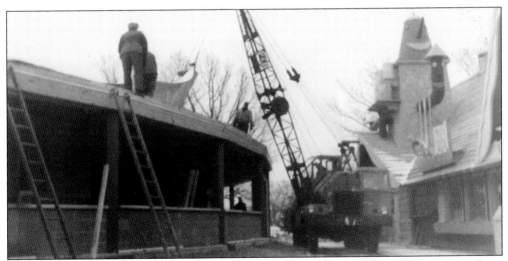

The entire Polar Dome project was quite an undertaking for Santa's Village Corporation. From start to finish, it set back the corporation nearly $350,000. The new attractions did help with attendance but never did offset the massive cost.

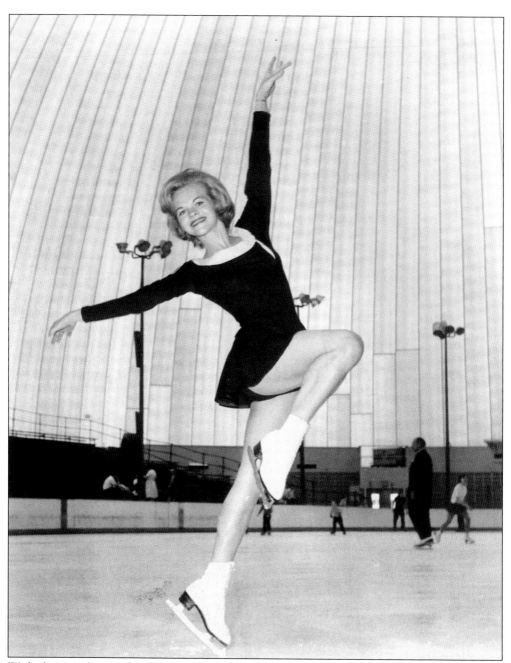

With the completed Polar Dome Ice Arena came new requirements for Santa's Village staffing. One of the first to come on board was professional ice-skater Andree Anderson Jacobs. A native Chicagoan, Jacobs was very instrumental in the dome's newly-created figure skating program. She began her skating career at Chicago Stadium and then went on to compete in national, international, and world competitions. She was a four-year touring member of Oscar Johnson's Ice Follies Skating Revue. Jacobs was the United States dance gold medalist and twice the over-all United States dance champion.

In this photograph, Santa's Village general manager Jack Morningstar welcomes Jacobs to the Polar Dome Ice Arena.

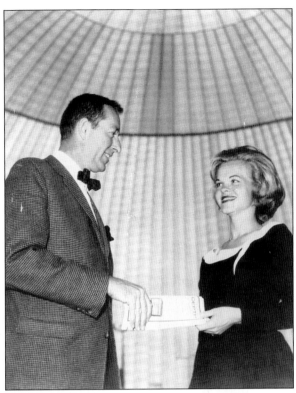

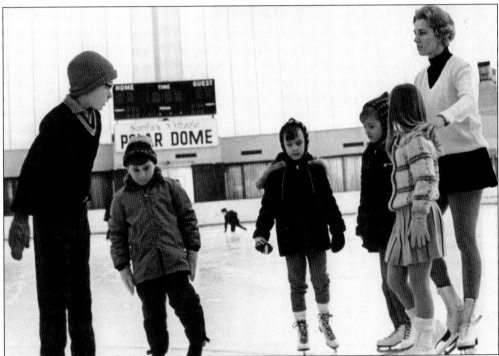

In the background of this photograph, one can see how massive the inside of the Polar Dome was. The top of the dome roof measured 87 feet from the ice surface.

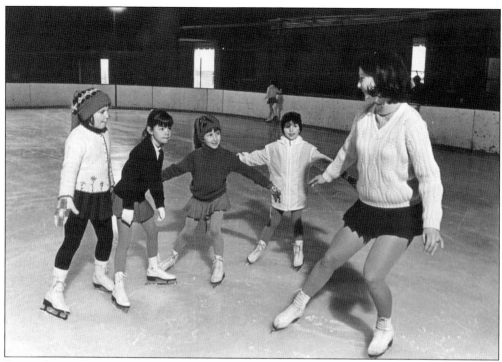

Figure skating lessons were an important part of the dome's attraction. Lessons were held for over 42 years.

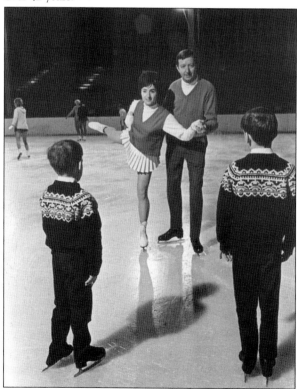

Mr. and Mrs. Jack Morningstar and their two sons enjoy an afternoon on ice at the dome.

With the Polar Dome being part of Santa's Village, one would never know who might be skating. Mr. Bunny takes to the ice during the Easter season of 1963.

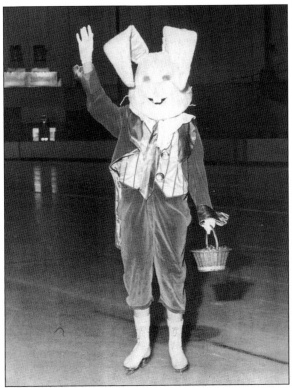

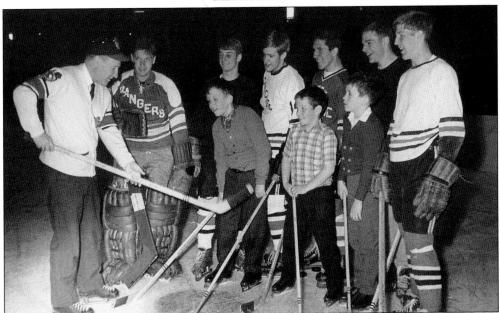

Ice hockey always played a very important role in the Polar Dome's history. Over the years, professional and amateur teams called the dome home, including the Chicago Hornets, the Elgin Blades, and the Fox Valley Astros. Some of the National Hockey League's Chicago Blackhawks practice sessions were held at the dome. The Blackhawks also conducted numerous hockey clinics for young players.

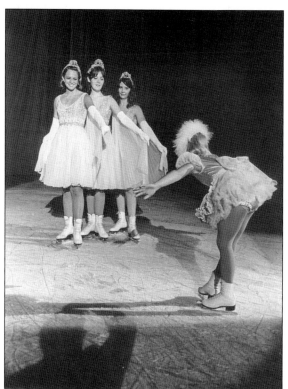

The Ice Follies Skating Revue played an important role in the early days of the Polar Dome Ice Arena. Between 1963 and 1965, numerous revues were produced by Oscar Johnson and Andree Anderson Jacobs.

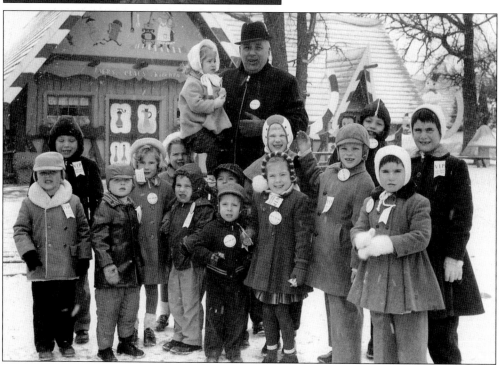

A group of children enjoy Santa's Village in December 1963. Even with the harsh winter weather the park continued to stay open until Christmas each year.

The spring of 1964 saw the addition of some short-lived attractions at Santa's Village. One such attraction was the Old Engine 99.

The Candy Cane Coaster along with Old Engine 99 were leased rides from Jack Kendrick Rides of California. Both the coaster and Old Engine 99 were removed in early 1966 with the completed sale of Santa's Village in Dundee to Durell Everding.

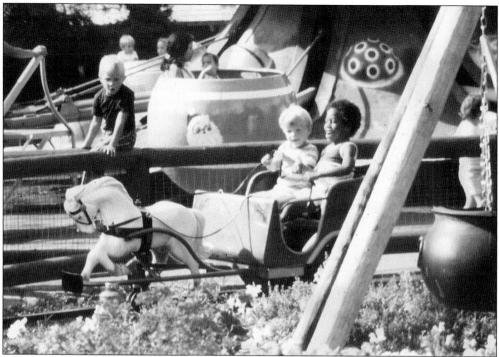

One of the most remembered rides at Santa's Village was the Pony Carts. Installed in 1966, the attraction remained until the 1987 season.

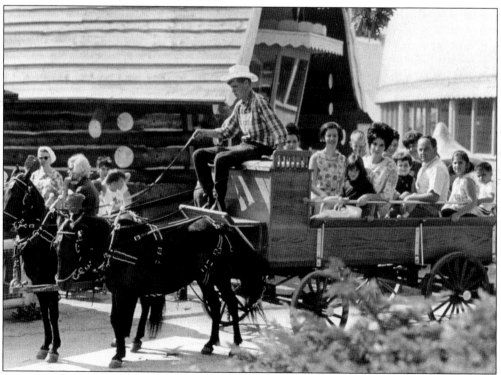

A buckboard wagon was added to help move the lines along on the Pumpkin Coach layout.

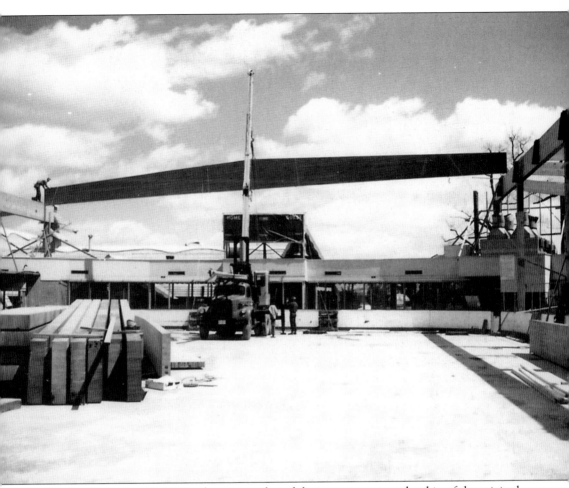

On Sunday, November 27, 1966, a huge gust of wind during a storm tore the skin of the original Polar Dome off. The dome skin was never intended to be permanent. It was expected that the air-supported structure would last from 5 to 10 years. Newly-designed dome blue prints were finished in March 1966, a full eight months before the storm came through East Dundee. The new design featured huge beams and a flat roof.

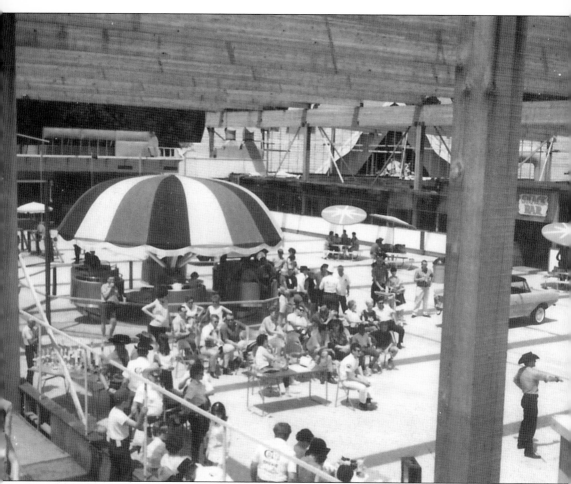

The reconstruction of the dome took over a year to complete. It featured a redesigned snack bar, a brand new lounge named the Alpine Room, and an expanded pro shop. Santa's Village opened in 1967 with the Polar Dome having a partial roof in place. The new roof was completed the following year.

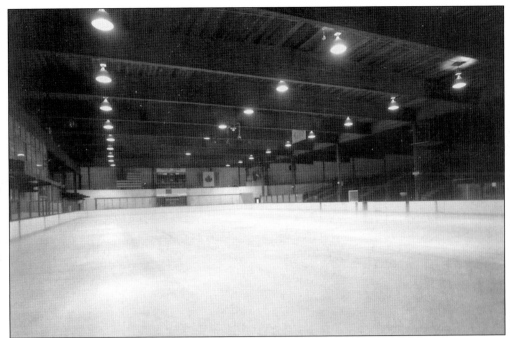

The dome of 1968 featured a new freezing system for the ice floor, a new scoreboard, and a new entrance.

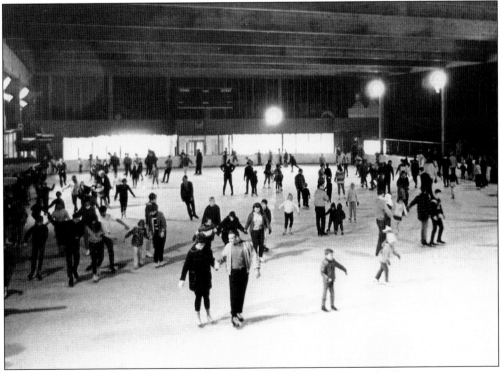

Even during the reconstruction of the dome, events and activities were held.

The Polar Dome Ice Arena started out as the largest air-supported commercial building in the world. It was host to hundreds of thousands of hockey and figure skaters. In its final years, the dome became a second home to those who gave so much of their talents and time to teach the children of the area how to enjoy ice-skating.

Four

SUMMERTIME FUN

With all the expansion that Santa's Village Corporation was undergoing in Dundee, Glenn Holland had miscalculated the park's operating season. Chicago-area weather was so unbearable and unpredictable during the winter months that attendance was low. Unlike its California predecessors, the park was put in the odd position of being closed at Christmas and financial problems ensued.

The year 1965 saw the end of Santa's Village Corporation in Dundee. Glenn Holland sold the park and its Illinois assets to Adventureland owner Durell Everding. During the Everding era, Santa's Village continued to adapt and grow. The main park opened on Mother's Day in May and closed the last weekend of October. The Polar Dome Ice Arena opened in September and closed in April. Everding also had a plan of adding new rides that would attract older children, thus making the park a total family experience. It worked.

Early 1970 saw the passing of Durell Everding. In 1972, a group of gentlemen known as the Medina Investors purchased the park. Barney Clark, the principal of the group, kept the park growing in the same direction as that of Everding. The name was changed to the Worlds of Fun theme park.

The worlds were Santa's World, the original area of the park, Old McDonald's Farm, which replaced the reindeer barn area, and the Coney Island section of larger rides and games of skill. Another theme park in Kansas City, Missouri, had a similar name. To avoid confusion, management added Santa's Village to the name again, thus becoming the Three Worlds of Santa's Village.

The tenure of the Medina Investors was relatively short, as in 1978 the park was once again put up for sale. The North Pole Corporation, owned by two McHenry County businessmen, took over the park with some new and bold ideas. They added a water and action park, Racing Rapids. The water park was one of the first in the Midwest and the largest in the state of Illinois when it opened in 1983.

The late 1980s through the early 1990s saw new growth in record attendance and in adding new and exciting attractions. Rides like Galaxi Roller Coaster, the Balloon Race, and the YO-YO were opened. Outdoor shows and new eating facilities dotted the park's landscape. With all the additional attractions, Santa's Village became a prime Chicagoland destination for summertime fun.

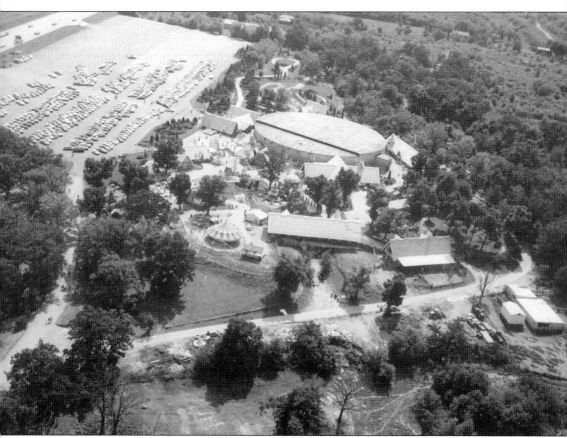

A birds-eye view of Santa's Village in early 1970 shows the redeveloped roof of the Polar Dome Ice Arena and some of the new attractions. Santa's Village had begun shortening its season during the late 1960s, under the new ownership of Durell Everding. Durell's company, Everding Management, also owned another Chicago-area park—Adventureland in Addison.

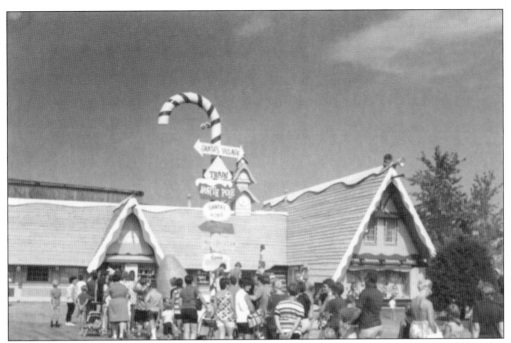

During the Everding era, attendance started to grow. The park was open year round, but not entirely. Santa's Village would open in May and continue into the fall season. The Polar Dome Ice Arena would open in late summer and continue until late spring.

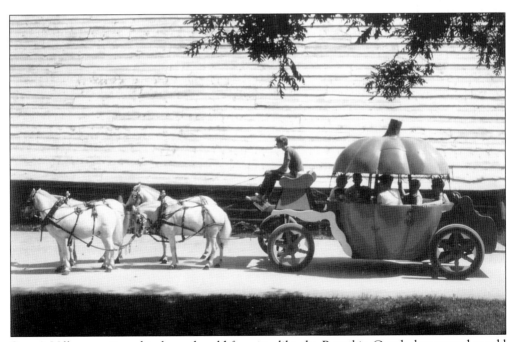

Santa's Village continued to keep the old favorites like the Pumpkin Coach, but started to add new rides that drew a more balanced customer base. In the 1960s, the village was geared more towards younger children and offered very little in terms of rides for older ones.

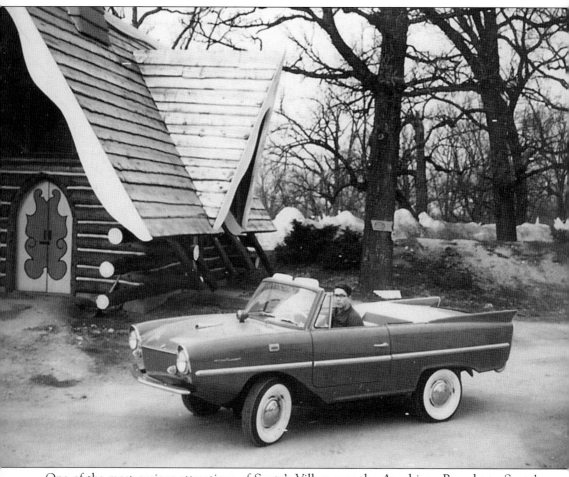

One of the most curious attractions of Santa's Village was the Amphicar. Brought to Santa's Village by general manager Jack Morningstar, the Amphicar was a miniature version of an aqua duck vehicle used by the armed services.

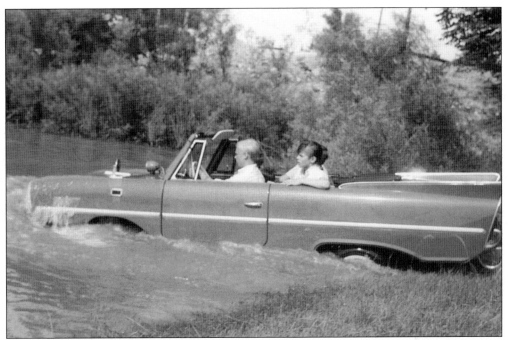

Picking up passengers on land, the Amphicar drove into the pond at the north end of Santa's Village.

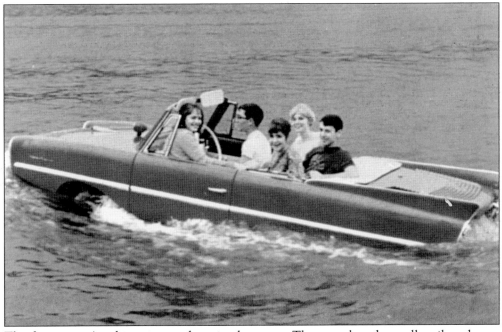

The five-seater Amphicar is seen here in the water. Those on board are all smiles—happy to be afloat.

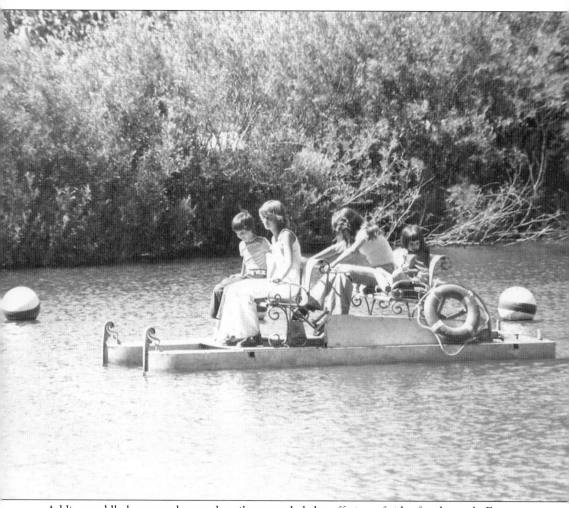

Adding paddle boats to the pond easily expanded the offering of rides for the park. Expansion and change were necessary if Santa's Village was to keep competing with other entertainment venues. In early 1970, Durell Everding passed away leaving the ownership of Santa's Village to his family. The family continued with the park until 1972.

One of the great selling points of Santa's Village came about with the development of the Picnic Grove. The Picnic Grove offered the guests the option to bring a packed picnic lunch and have a shady wooded area to enjoy it. Located at the north end of the property, the Picnic Grove had an entrance from the parking lot and from inside Santa's Village.

With five acres of picnic space available, Santa's Village became the perfect place for families, companies, and organizations to have private gatherings. With picnic planning specialists, the park made an outing simple, fun, and memorable.

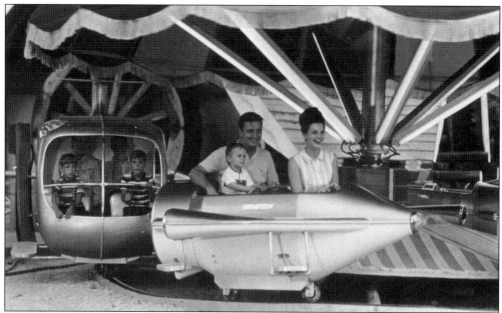

Children of all ages continued to enjoy Santa's Village. The park was fast becoming a changing canvas. The Everding family decided to sell Santa's Village in 1972 to a group of businessmen known as Medina Investors. Barney Clark acted as the principal of the group. That same year, the general manager's job was taken over by Don Holliman. Holliman had started his career with Adventureland in 1962 and had been managing the Polar Dome Ice Arena since 1968.

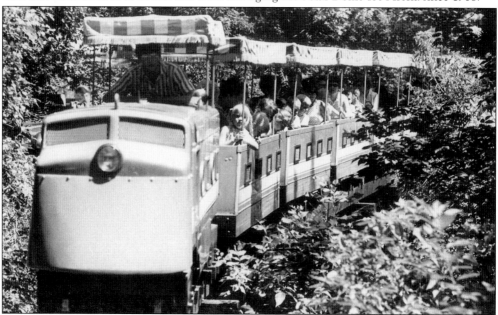

Here the Santa's Express Train rounds the bend through the Enchanted Forest. The train track layout inside the park was shortened and a train was brought over from Adventureland. In Don Holliman, Santa's Village found a general manager that promoted the rides first and the other intangibles second. Holliman understood this new reality of the amusement business. The profit centers of a park were the gate, rides, foods, games, and then merchandise.

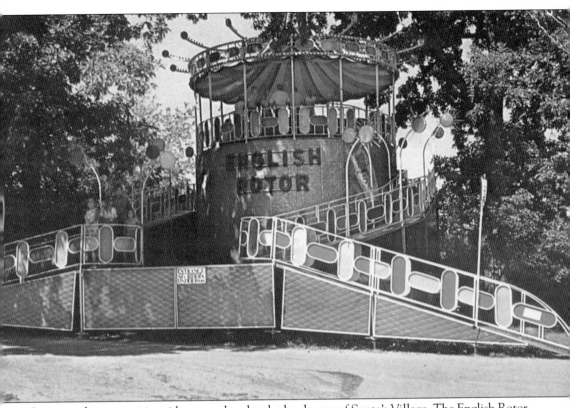

Larger and more exciting rides started to dot the landscape of Santa's Village. The English Rotor was a popular attraction that spun riders in a large drum area backwards and then forwards.

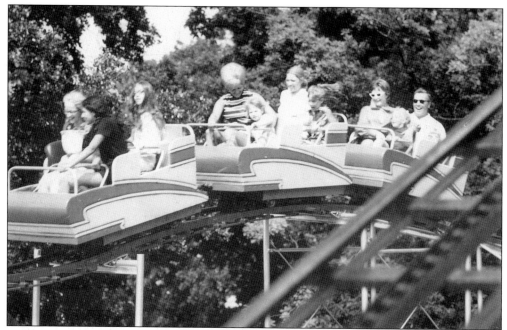

Roller coasters played an important role in the summertime attractions of Santa's Village. A few years after the Candy Cane Coaster was removed, the park's second coaster, the Cannon Ball Roller Coaster, was installed. The Cannon Ball was a simple out-and-back ride that was suited for both children and adults.

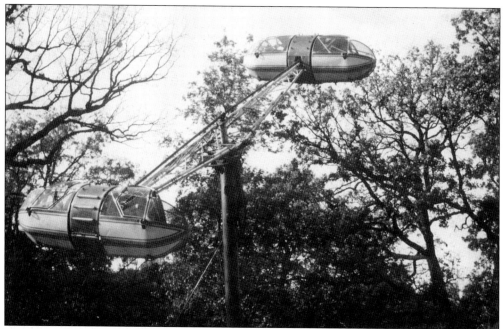

The Rollo Plane, also known as the salt and pepper shakers, kept in pace with the new direction of Santa's Village. Areas of the park started to take on new personalities. Larger rides were placed on the south end of the property, while the children's rides were on the north end. This, of course, was by design.

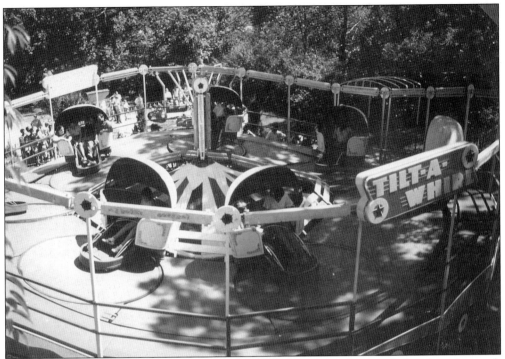

The Tilt-a-Whirl was another ride brought over from Adventureland and placed in the south end of the park. The south end became the best place to put the yearly addition of new rides.

Eventually the south end of Santa's Village was dubbed Coney Island. One of the features was the Swiss Toboggan. The toboggan contained enclosed cars that rode on 450 feet of track that was spiraled around a 45-foot center column.

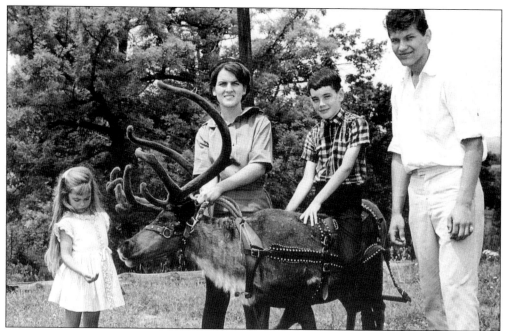

Santa's Village was slowly but certainly changing with the times. The days of reindeer and pixies were fading. Discussion of a name change came into the question. With more theme parks dividing their properties into different sections, Santa's Village considered following the pattern. It made good business sense, and it was a way for the park to show and market a product that was more than the name implied.

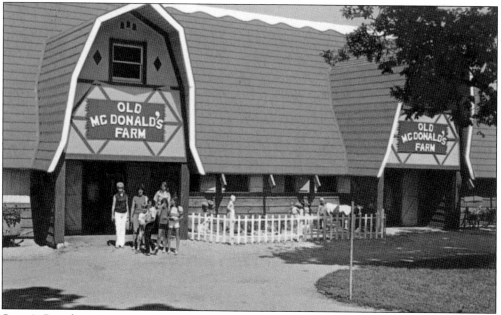

Santa's Reindeer Barn was updated to Old McDonald's Farm by 1971. The area contained a petting zoo where visitors fed small farm animals. Children came face to face with goats, chickens, pigs, and cows. Even some exotic animals such as fawn deer, peacocks, and llamas were seen up close.

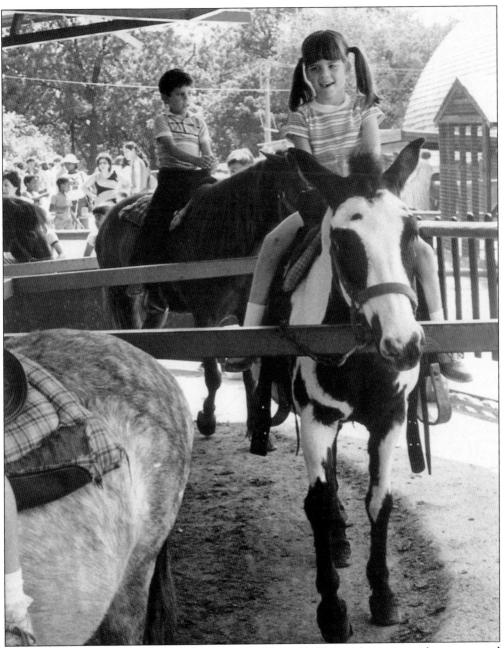

Animal rides also were featured at Old McDonald's Farm. Children rode ponies or a horse-powered carousal. The old Candy Cane Sleigh was incorporated into this section and used horses instead of reindeer.

Another growing element of Santa's Village was the shows. Live entertainment gave the family a breather from the rides to enjoy some local talent. By 1976, Santa's Village became a multithemed park with three worlds of fun. The worlds were Santa's World, Old McDonald's Farm, and Coney Island.

Other attractions such as bumper cars, games of skill, and eating facilities started to dot the landscape. The name Worlds of Fun started to be used. A Kansas City, Missouri-based theme park had a very similar name and their representatives contacted Santa's Village management. To avoid confusion or any legal actions, the name Three Worlds of Santa's Village was adopted, but the name was confusing and never really caught on.

Attendance started to wobble a little and, once again, Santa's Village was up for sale. The Medina Investors placed an advertisement for the park in the *Chicago Tribune* real estate section. Hugh Wilson, a machine operator that worked for the state, saw the advertisement and approached his friend, businessman Philip Oestreich, about a partnership. Together they bought Santa's Village and formed the North Pole Corporation.

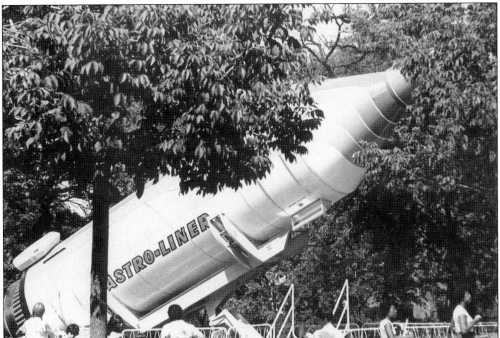

Under the North Pole Corporation, Santa's Village kept adding new rides, shows, and attractions. One of the attractions produced was the Astro-liner where the rider experienced an enclosed, controlled simulation of a space mission.

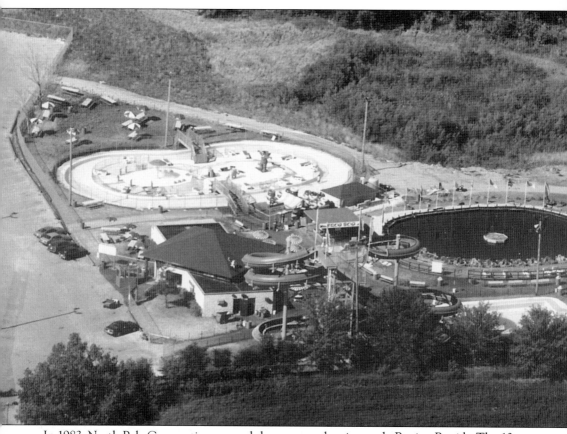

In 1983, North Pole Corporation opened the water and action park, Racing Rapids. The 10-acre facility was the largest water park in Illinois at the time. The park featured waterslides, go-carts, and tube slides. The Twister Tube Slide by itself required 4,000 gallons of water per minute.

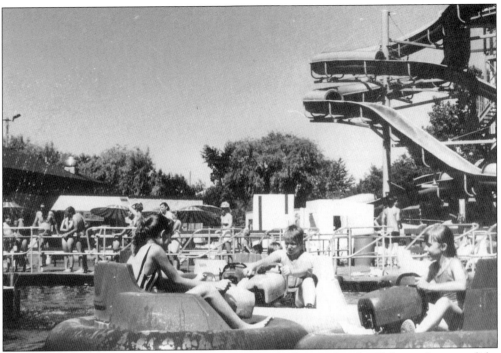

Park-goers navigate their own bumper boats. In the background is the Slide-winder waterslide. At a towering 52 feet, the slide actually had two tubes to slide down.

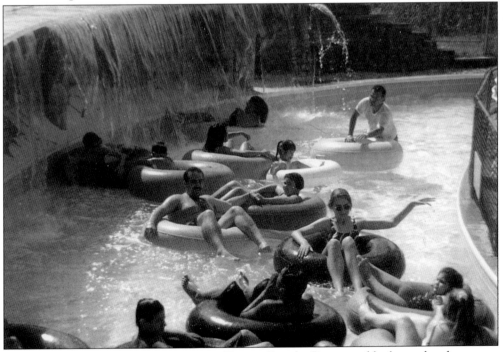

The Lazy River was a popular attraction of Racing Rapids. Guests could relax and soak up some rays on this 450-foot-long inner-tube floating course featuring Fiji Falls. In the middle of the Lazy River was Children's Fun Island.

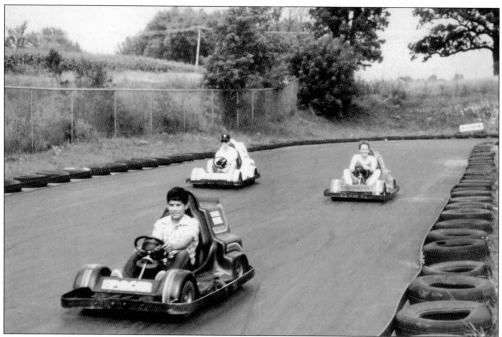

Driving the Grand Prix Go-Karts around the curvy track was one of the most exciting attractions of Racing Rapids. Admission to Racing Rapids was done in two ways: a single ticket or the combination ticket that included Santa's Village.

The new games of skill at Santa's Village ranged from the basic ring-a-bottle to the animated shooting gallery.

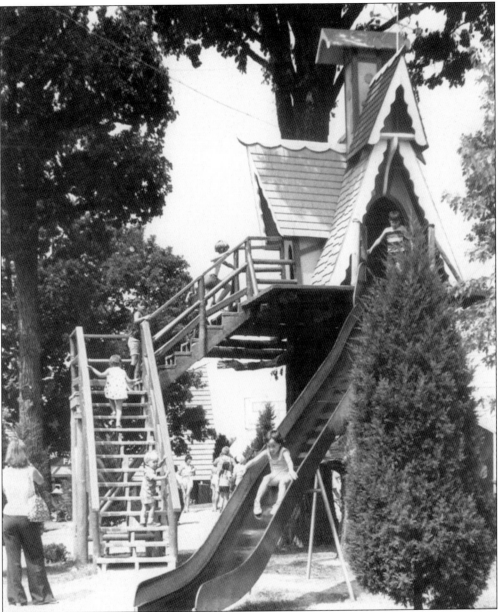

Throughout the years at Santa's Village, the Tree House Slide was enjoyed by millions. The slide was the only original ride left in the village by 1993. It remained unchanged and reminded all, no matter what the year, of a simpler time.

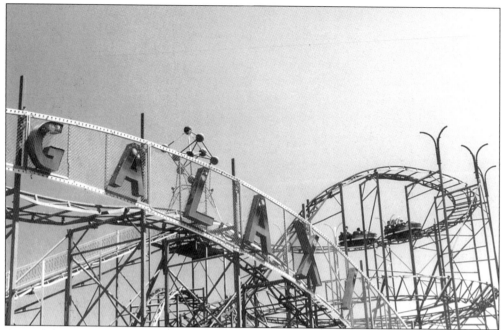

One of the biggest and best attractions Santa's Village ever offered was the Galaxi Roller Coaster. This all-steel coaster stood six stories tall and curved around within its own framework. The Galaxi was placed next to the Welcome House created from part of the Pumpkin Coach and then later the Fire Truck layout.

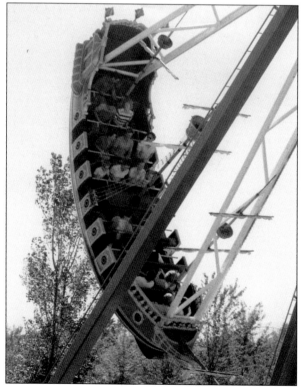

North Pole Corporation added a big addition to the Coney Island section of the park with the Galleon Pirate Ship. It remained a very popular ride until it was sold at auction in October 2006.

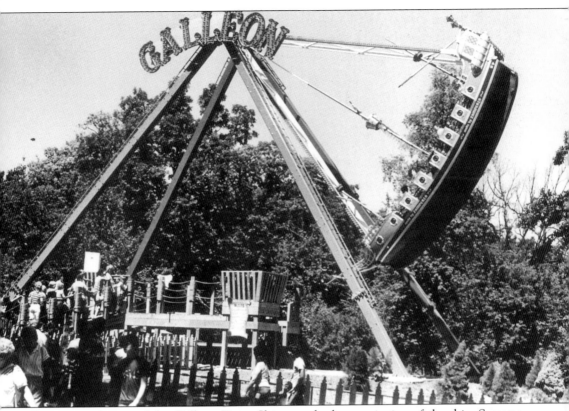

The greatest feature of the Galleon Pirate Ship was the huge swinging of the ship. Screams of fun were heard all over the village. When visitors walked the pathways beside the ship, it appeared to be headed right at them.

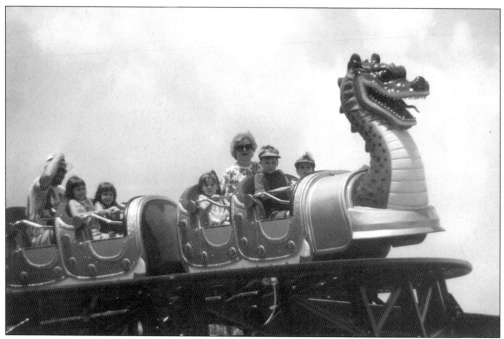

Replacing the Cannon Ball Roller Coaster in 1986, the Dracor, the Dragon Coaster became a favorite of the smaller guests. The ride was so popular that Santa's Village actually had to replace the first Dragon Coaster with a new one in the late 1990s.

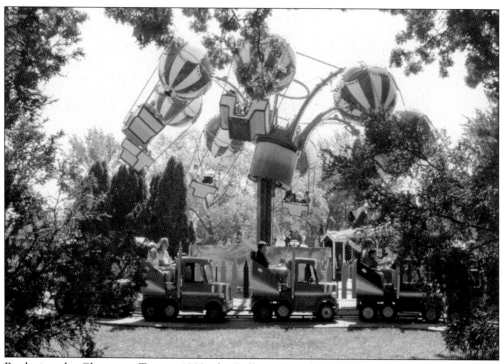

Replacing the Christmas Tree in 1992, the Balloon Race became a tradition all its own. The Convoy Trucks, which replaced the Pony Carts in 1988, also became very popular.

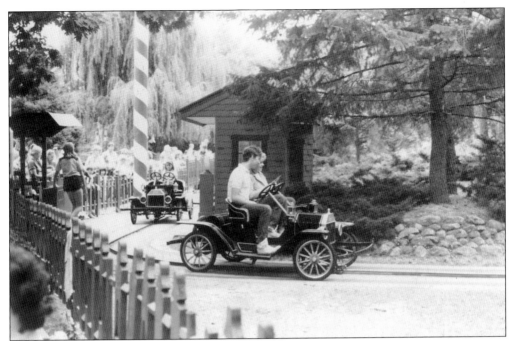

The Antique Cars have thrilled millions since being part of the Polar Dome project. Opening in 1962, all the original cars were used until the village closed in 2005.

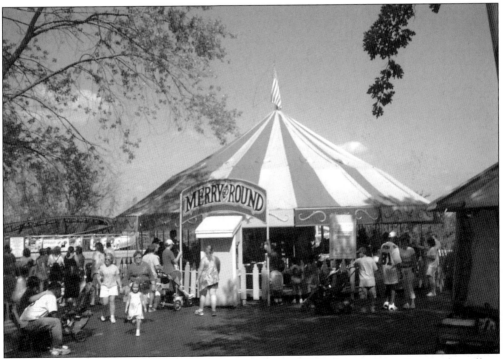

The Santa's Village Merry-Go-Round was installed in 1966. It was the only one the village ever owned.

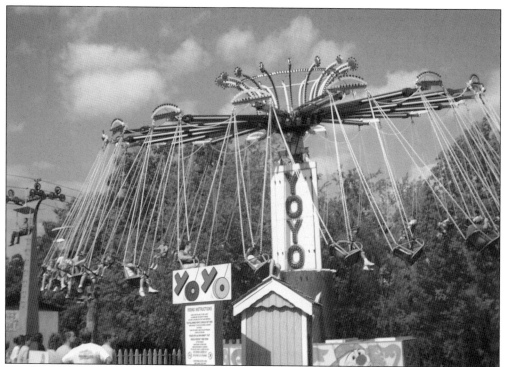

Installation of big rides continued in the Coney Island section with the addition of the YO-YO in 1990.

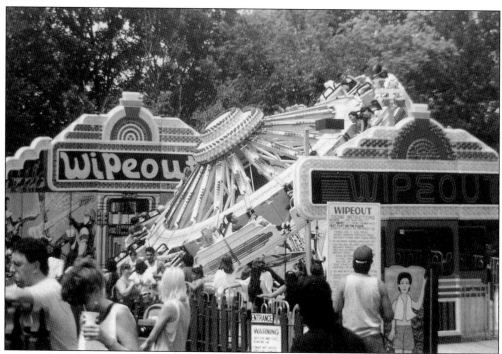

With rock and roll music filling the area, the Wipeout was a favorite with the teenagers. Along with the Balloon Race, the Wipeout was installed in 1992.

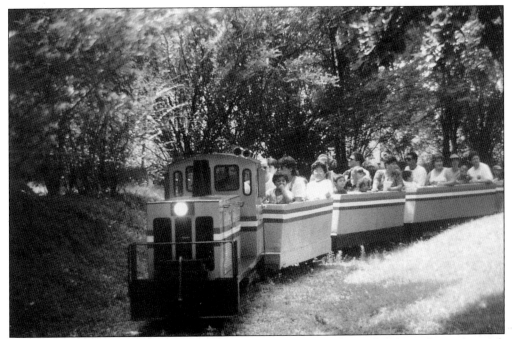

Santa's Village replaced the Santa's Express train in the summer of 1994 with an Amtrack version. The repainted passenger cars from the express train follow the engine.

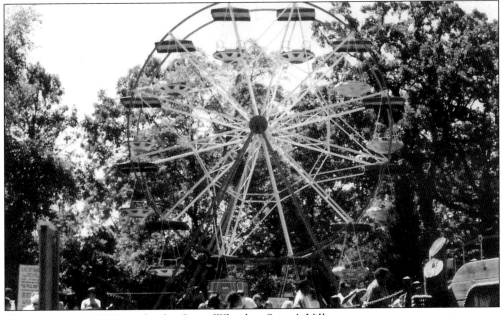

The summer of 1995 brought the Great Wheel to Santa's Village.

Over the years, Coney Island has added to the Santa's Village experience.

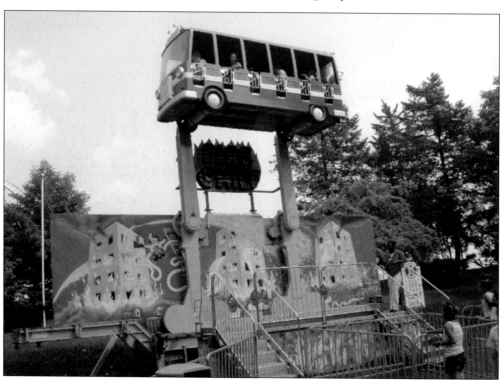

While spinning vertically, children scream on the Fire Chief version of the Crazy Bus.

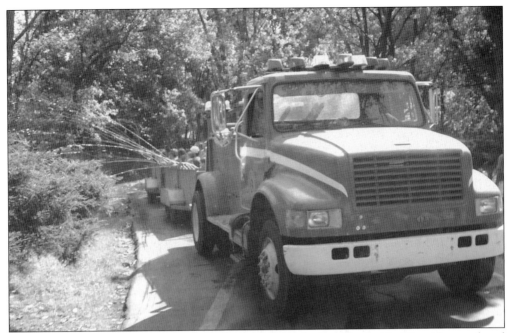

Another attraction that came from Adventureland was the Fire Truck ride. The ride was placed on the Pumpkin Coach layout in the mid-1970s. Children loved using the miniature fire hoses to help extinguish a small burning house. Most of the time more water was sprayed on their parents than the burning house.

Even after 46 years, Santa's Village still offered family fun. There was no better place to spend a bright, sunny day.

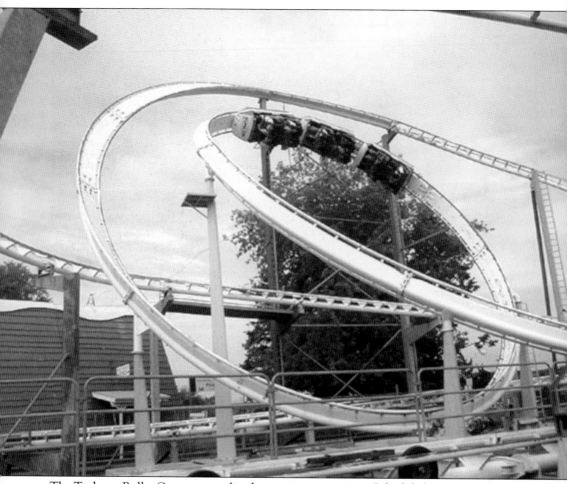

The Typhoon Roller Coaster never lived up to its expectations. Scheduled to open in the summer of 1997, the Typhoon was a disaster from the start. The park had trouble getting parts from overseas through customs. Management had put film footage of another Typhoon in the park's television commercial and went to air with it. When patrons got to the park to ride the Typhoon, all they saw was a lot of iron. The ride never really got going until mid-1998, and by then, the damage had been done. It cost Santa's Village a lot more than the $1.5 million price tag.

Content to watch the little ones, most parents were happy that they were too big to hop up and down on the Frog Hopper.

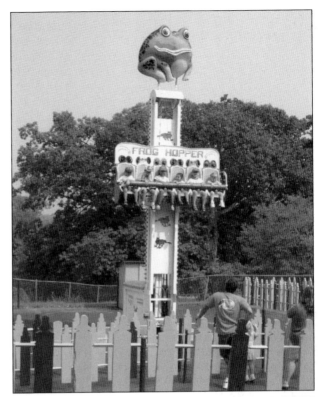

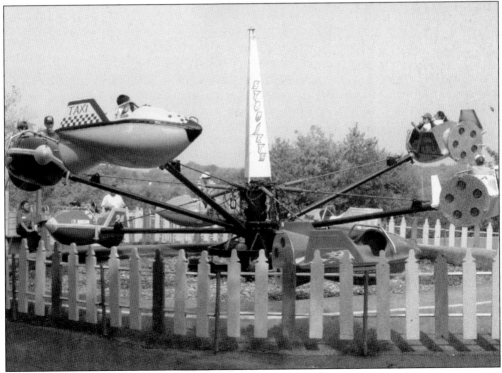

Taking flight to the stars, little astronauts fly their own Star Jets.

The Magic Pond was more of a wishing well than a pond. Each season, thousands of guests would toss in a penny and make a wish.

People start to line up outside the Evergreen Theater to participate in *Santa's Snowstorm Game Show.*

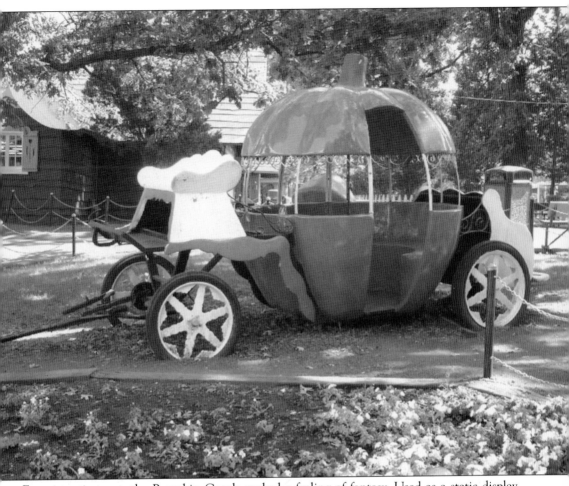

Even in retirement, the Pumpkin Coach evoked a feeling of fantasy. Used as a static display during the last 20 years, the Pumpkin Coach was a popular photograph opportunity for guests.

The most loved and recognizable ride in Santa's Village history was, by far, the Snowball.

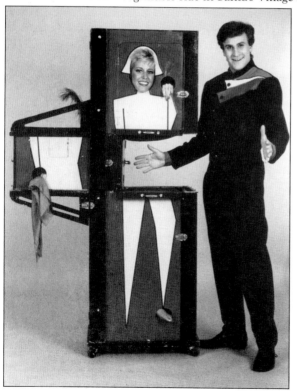

The amazing magic of Tim and Robin Balster entertained audiences at Santa's Village for 13 years. Their *Boardwalk Magic Review* was the longest-running show in park history. The Balsters also produced *Santa's Snowstorm Game Show*. The show was a thrilling game where randomly-selected audience members participated in wild and crazy games. The final winner entered the snowstorm chamber and grabbed "Santa Bucks" as they swirled about.

Five

THE HOME OF SANTA CLAUS

For 46 years Santa's Village had been the home to Santa Claus. Each day hundreds of children, parents, and even grandparents lined up at Santa's House to pay a visit. Children loved to sit on Santa's knee and whisper their Christmas wishes into his ear even though it might be June or July.

When venturing up to Santa's House, one could see and touch the frozen North Pole right outside the front door. The "Pole" stayed icy even on the hottest summer days. At the front door a giant key unlocked the secrets of the home to visitors. Inside Christmas music filled the air along with the scent of freshly baked cookies. Santa would tell stories, have the children sign his Good Book, and remind them of how many days there were to Christmas.

Santa's duties were not confined to his house. Often he could be seen throughout the park greeting guests, riding a ride or feeding the deer. There were even times that his presence was required outside the gates of Santa's Village.

No matter what decade or changes the park made, Santa talked and visited with everyone just as he had since 1959. Santa's House, the North Pole, and Santa Claus made childhood fantasy a magical memory for children of all ages.

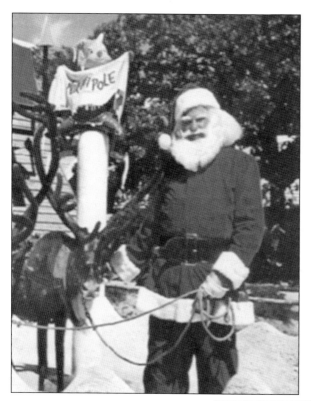

The Dundee village's original Santa, James (Jim) L. Combs, a native of northern California, is pictured at left next to the North Pole in 1959. Combs trained to be Santa for the Dundee village in 1958 at the Scotts Valley Santa's Village under Carl Hansen. Hansen, a native of Denmark, was the official Santa trainer for all three parks. As Santa Claus, Hansen opened up the Skyforest village in 1955 and the Scotts Valley village in 1957.

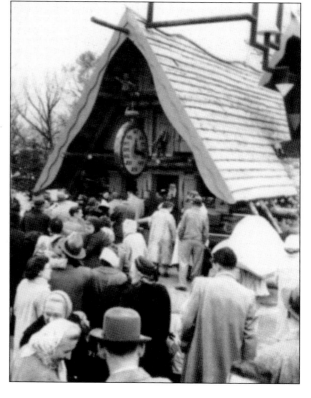

A long line waits to see Santa in 1959. For over 46 years, Santa's House was home to jolly old St. Nick. This storybook cottage hosted hundreds of thousands of children who spent a magical moment with Santa Claus. Filled with antiques and set near the center of the park, the house was a nostalgic example of old-time Christmas spirit and hospitality.

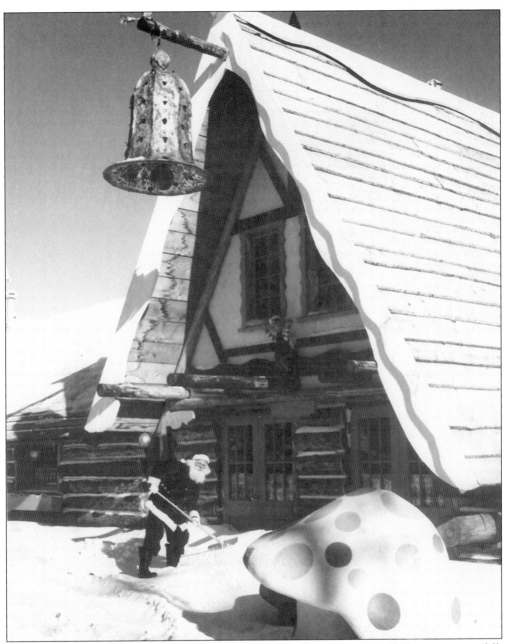

Known as Santa Jim, Combs grabs a snow shovel to help out during a 1960 winter snow fall. He relocated from northern California with his wife and daughter Jenna to East Dundee in 1959. The Combs family were employees of all three Santa's Villages at one time or another. Mrs. Combs made costumes and worked with her daughter in the Wee Puppet Theater. Santa Jim continued in the role of Santa until the end of 1961, when he and his family returned to the Scotts Valley, California, area.

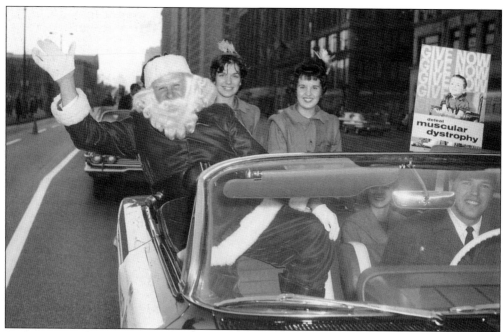

Santa and his helpers assist the Muscular Dystrophy Association with a tour of Michigan Avenue in downtown Chicago. Throughout the years, Santa's Village helped many charitable organizations. Besides the Muscular Dystrophy Association, the park has worked with the United States Marine Corps Toys for Tots program and numerous local Chicagoland charities.

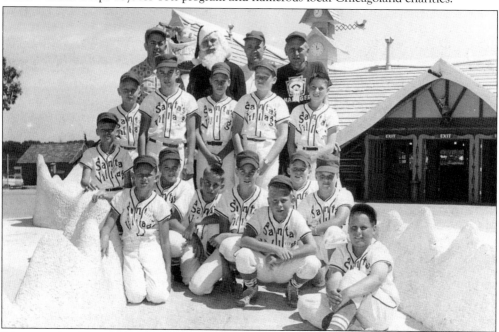

Like many local businesses of the 1960s, Santa's Village sponsored a Little League baseball team. This team photograph was taken on the cement snow path that surrounded the North Pole before it was relocated during the building of the Polar Dome Ice Arena. The uniforms worn by the boys on the team are a rare collector's item. Only a few still exist today.

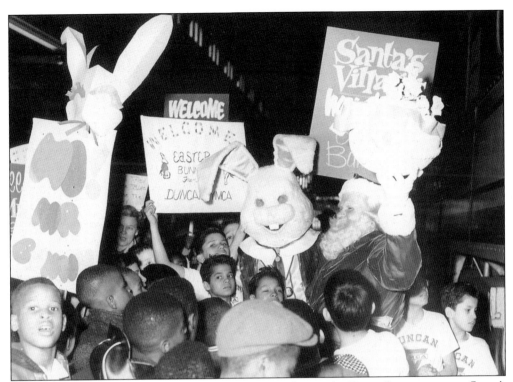

Santa Claus and friends from the Duncan YMCA welcome the Easter Bunny to town. Santa's Village's public relations department always came up with creative ideas to promote the park's upcoming season.

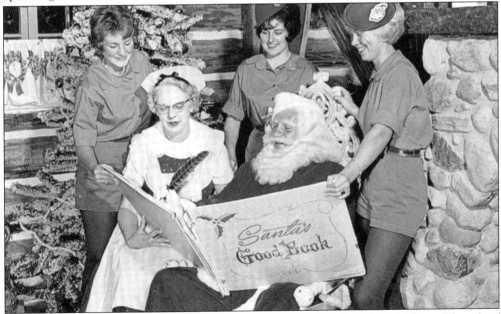

Santa, Mrs. Claus, and three of their helpers check the Good Book in Santa's House. The role of Santa Claus was taken over by Eric John Lavoie in 1962. Better known as John, Santa Eric was the park's main Santa until 1965.

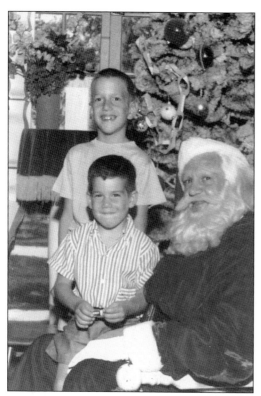

Besides his duties visiting with children in the park, Eric John Lavoie, or Santa Eric, also appeared in three movie shorts produced by Florida-based producer, K. Gordon Murray. The shorts were filmed at Santa's Village in Dundee in 1964 and 1965. The first movie, *Santa Claus and His Helpers*, was released in the fall of 1964 and the other two films, *Santa's Magic Kingdom* and *Santa's Enchanted Village*, were released in 1966.

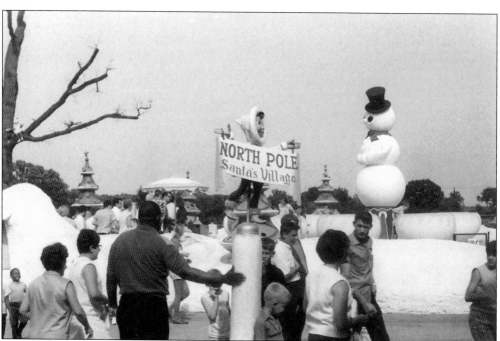

The Frozen North Pole always amazed young and old alike. The pole was relocated next to the Snowball near Santa's House in 1962 with the construction of the new Polar Dome Ice Arena. This would be the pole's second location in the park.

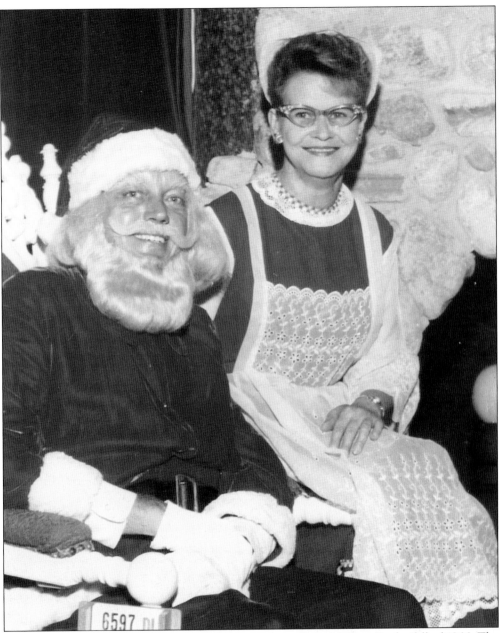

Santa and Mrs. Claus take time to pose for a picture in Santa's House in the fall of 1966. The duties of Santa Claus were taken over full time that year by Don Goers. A native of Algonquin, Goers came to Santa's Village in 1959 as a maintenance man and helped out wherever he could. One day, he and another park employee were working on the Snowball Ride when Santa walked up and asked if they knew of anyone who could help him out and give him a day off. Goers spoke up and said, "Yes, I do . . . me!" Goers was the main Santa from 1966 to 1979.

Don Goers, or Santa Don, talks with two sisters in Santa's House. Visiting with children of all ages was part and parcel of the job. Being the Santa from Santa's Village was a very recognizable role. Not only did Goers play the park's namesake, he was seen at Christmas events all around the area. A lot of children from the Fox Valley region remember the Santa from the Joseph Spiess Department Store in downtown Elgin. That was played by Goers also.

Santa Don and his helpers take a moment to pose for a photograph next to Santa's House in 1972. The helpers wore the pixie costumes into the 1970s. Notice the North Pole in the background. The pole was located closer to Santa's House in 1968 after the new roof was put on the Polar Dome Ice Arena. This was the third and last location of the North Pole in the park.

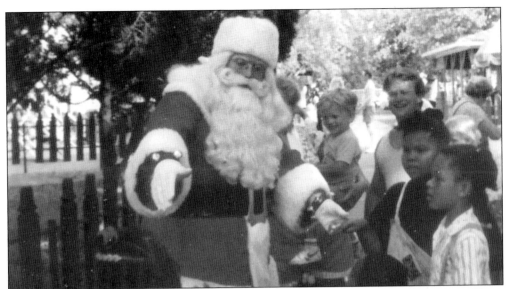

Phillip L. Wenz first came to Santa's Village in 1986 through a contract with Instant Photo Corporation of America. Shortly after leaving college in 1985, he was hired to be Santa Claus by Instant Photo Corporation of America's owners Martin and Shelia Chasen. "Marty and Shelia are wonderful people to whom I owe a lot," recalled Wenz. "My job for them was to train Santas and set up holiday promotions in the Chicago area. One of Instant Photo's accounts was Santa's Village. In 1989 I formed my own company and was contracted by Santa's Village to become their resident Santa."

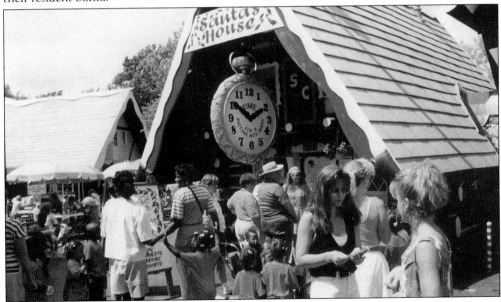

Santa's House became Wenz's second home. Under an agreement with North Pole Corporation, the owners of Santa's Village, he had control of the look and feel of Santa's House and used a lot of his own props and costumes. Wenz completely restored the house in 1991 and updated it again in 2004 for the park's 45th anniversary. General manager Don Holliman, operations director Crystal Varney, and the park's owners, Hugh Wilson and the late Philip Oestreich, were always kind and receptive to ideas.

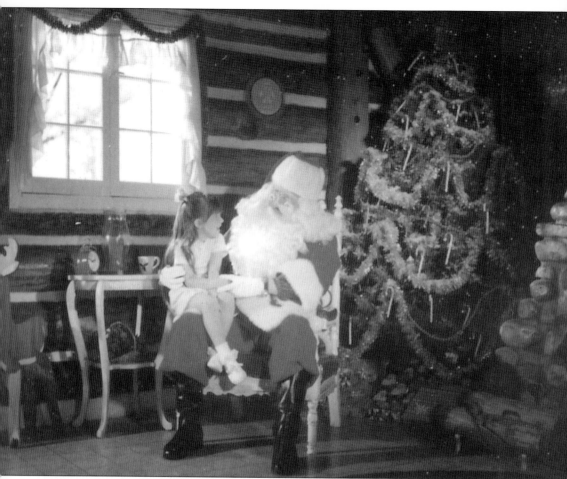

In 1992, public relations director Jill Gewetski came up with an advertising concept for the upcoming season that would be more of a home movie for Phillip L. Wenz than a commercial. The Just A Dream Away campaign would become a family affair as Wenz's four-year-old daughter, Holly, was cast as the little girl who dreams of a day at Santa's Village. Over a two-day period in June three hours of film were shot of Wenz's daughter on almost everything the park had to offer. The above photograph is a still shot of Holly and Santa from that campaign.

Part of the fun of being the year-round Santa Claus is that no matter what month of the year it is, children are always happy to see Santa. Santa's Village is Santa's home. Santa is able to meet and greet the young at heart anywhere in the 40 acres.

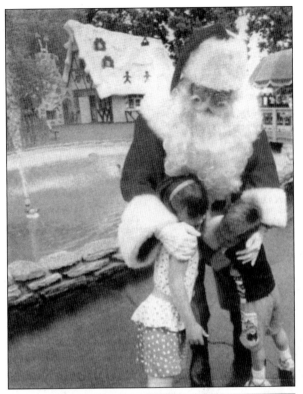

Just as Phillip L. Wenz's predecessors, part of being Santa from Santa's Village is doing more than being at the village at all times. Over the years, Wenz has appeared in more than 25 parades including televised parades in Chicago and Houston, Texas. From Christmas tree lighting ceremonies to visits with state governors and city mayors, being the Santa from Santa's Village has given Wenz a lifetime of treasured experiences.

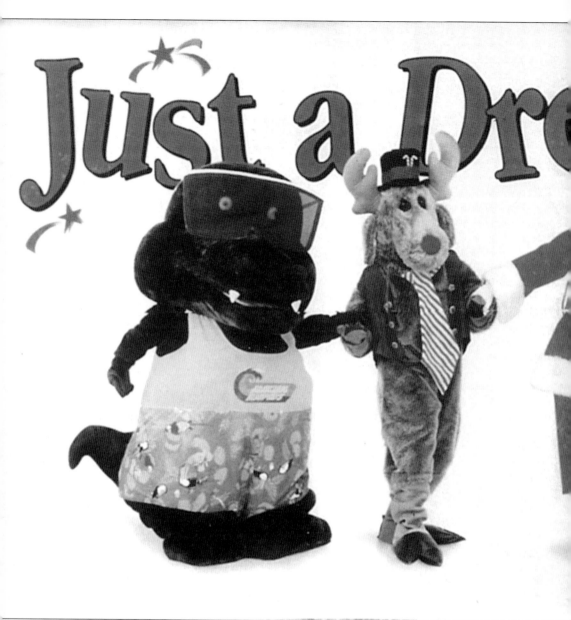

The characters of this billboard are lined up similar to an advertisement for the *Wizard of Oz*. The Mistletoe Moose between Racing Rapids mascot Alligator Dundee and Santa Claus is

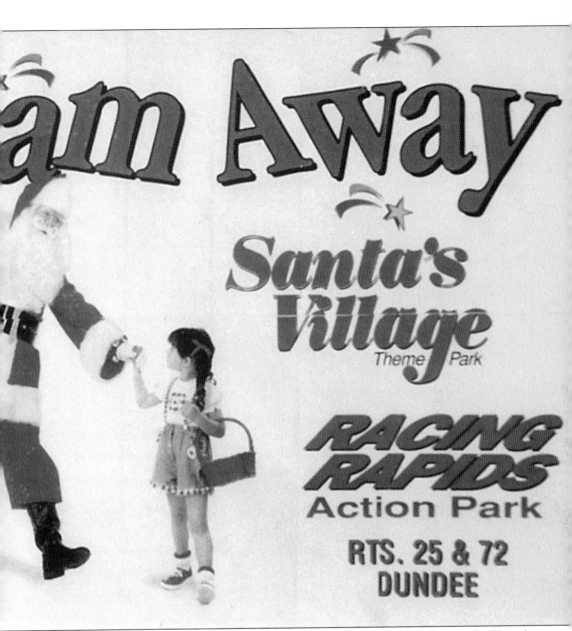

public relations director Jill Gewetski. Gewetski gave Phillip L. Wenz a set of the actual billboard sheets, and to this day he still has the larger-than-life picture.

At the beginning of the 2005 season at the park, Phillip L. Wenz removed the large pocket watch that had hung over the door for the previous 45 years. He planned on redoing it, and replaced the pocket watch with a large five-foot wreath. As the season progressed and no one knew if the park would open for the 2006 season, he decided to leave the wreath in place. The wreath symbolized the change that was about to happen. The pocket watch was put in safe storage and will be refinished.

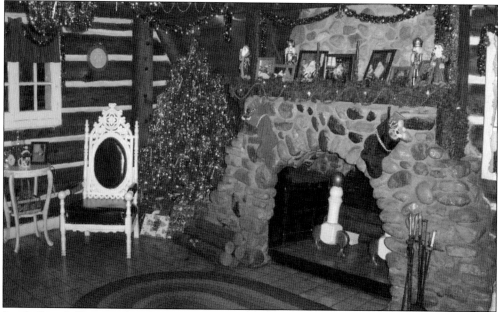

Inside Santa's House is the chair that all who have played the character sat in and all those that have sat on Santa's knee have been photographed with. It is a park original. The chair and the other original props of Santa's House, including the frozen North Pole and Santa's sleigh bed, were not auctioned off. They are in safe keeping in Wenz's personal Santa's Village collection and one day may again entertain those who believe in Santa.

Sitting at the Good Book desk and checking the list twice was a daily function of Santa in his house. There are many in this Good Book, especially those who helped out Santa at one time or another. Besides James L. Combs, Eric John Lavoie, Don Gores, and Phillip L. Wenz, others have donned the red suit to help with a season. They included Alan Payne, Harold Chud, Greg Slovacek, John Carter, Bill Sadowski, Nick Christoforakis, Keith Straus, Jeff Little, and Shawn Conway.

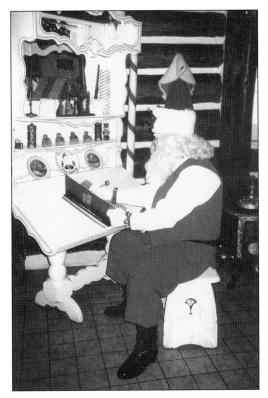

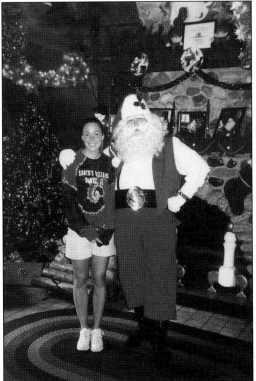

Part of the visitor's experience in Santa's House was the hospitality of the helpers who took pictures and helped the guests with their visit. Over Phillip L. Wenz's tenure at Santa's Village, he had some great helpers including Gail Krupp, Rachel Curran, Penny Stokes, Christian Kennedy, Bridget Ash, Stephanie Ash, Vicki Pawlick, and Mallory Krueger. Pictured here is Jacqueline Huber, who was one of the last helpers.

Inside Santa's House one saw Santa's sleigh loaded with Christmas goodies, a beautiful tree that stayed up all year long, and the huge cobblestone fireplace that warmed the home on those cold winter nights. Children sat at Santa's desk and signed his Good Book. Twinkle lights, decorations, and wrapped packages adorn the rafters. Imagine the wonder on a child's face when he or she came into this house of real make-believe.

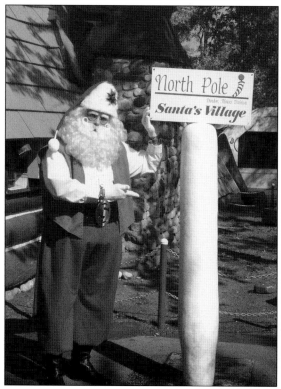

September 18, 2005, was to be the last day that Santa Claus would entertain children of all ages by the North Pole and in Santa's House.

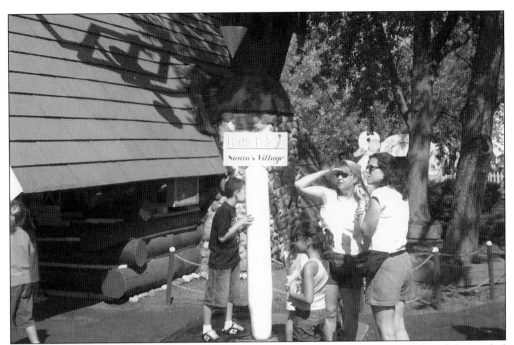

Even on that last day the North Pole was to be frozen at the park, children still found the icy feel magical and fascinating. The North Pole survived three locations, numerous signboard toppers, and the summer sun, but most importantly, it fascinated millions.

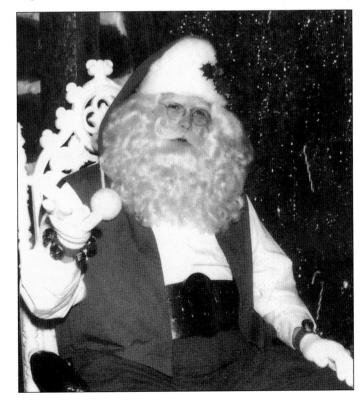

What started at the original Santa's Village in Skyforest, California, in May 1955, with Carl Hansen as Santa Claus, ended with Phillip L. Wenz 50 years later at the Dundee park in 2005.

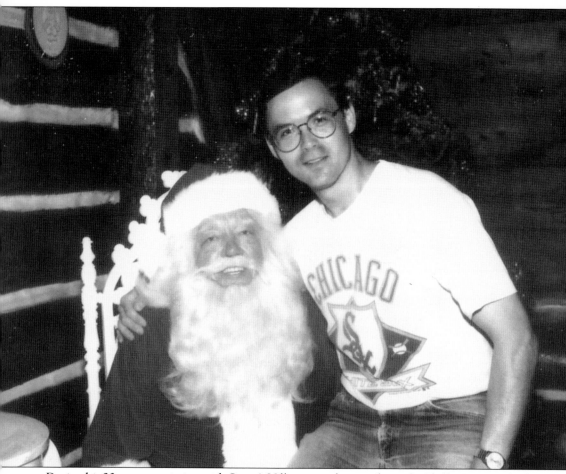

During his 20-year association with Santa's Village, one day stands out for Phillip L. Wenz (right) more than any other. In June 1994, during the park's 35th anniversary year, he relinquished the Santa role and Santa's House for a day to his best known predecessor, Don Gores. That day he got to watch the Santa that he knew as a child do an encore performance. Gores did what he did best: entertain children. The magic came back into his eyes as he walked in Santa's House for the first time in 15 years. Of course, the first kid in line that day was Wenz.

Six

SLEIGH BELLS
RING NO MORE

May 2004 was the 45th anniversary for Santa's Village in Dundee. Very few theme parks achieve the milestone of becoming a park with five generations of visitors. Santa's Village provided a way for children to experience some of the same attractions that their parents experienced as children.

At the close of the 2004 season, Sterling Bay Companies, a Chicago-based real estate development firm, purchased the land on which Santa's Village sat. Rumors were spreading that Santa's Village would not reopen. On Mother's Day in 2005, the park opened as usual. It became Santa's Village's 46th and last season.

That same year, a group of East Dundee businessmen known as North Pole Village, LLC, approached North Pole Corporation to buy the assets of Santa's Village along with the land that the park sat upon. The land lease held by North Pole Corporation was set to expire in March 2008. If the deal was successful, North Pole Village, LLC, would have put Santa's Village assets and land together for the first time in history; however, in June 2006, the deal was in default.

In August 2006, judgments against both North Pole Corporation and North Pole Village, LLC, were handed down by the Kane County circuit court. Both companies were evicted from the park property. Long time owner North Pole Corporation held an October 2006 auction of the non-fixed assets. The infrastructure stayed in place. Sterling Bay Companies kept their options open as to the future of Santa's Village. In January 2007, the property was listed for sale and was closed to the public.

Over the years, Santa's Village remained true to its origins and family orientation. What does the future hold for the site of Santa's Village? It is hard to say, but one thing is for certain, Santa's Village was a Chicagoland tradition.

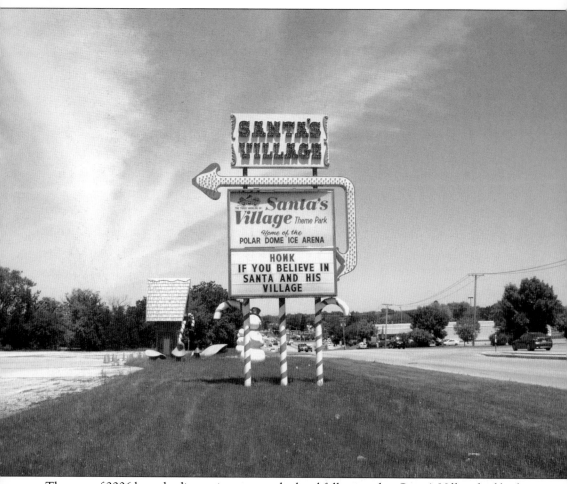

The year of 2006 brought disappointment to the loyal following that Santa's Village had built up over the years. It started out with the hope of a new owner for the park and a new era. It brought hope of retirement for the owner of 28 years and the promise of putting the assets together with the land for the first time in history. A group of East Dundee businessmen known as North Pole Village, LLC, made many promises but did not have the funding to back them up. By May, it was obvious that things were not falling into place, and the promises were broken. All of the family outings, picnics, and group trips were canceled. Employees, vendors, entertainers, and contractors were laid off. Numerous contracts and payrolls were not honored. It ended with the former owner, North Pole Corporation, selling off the non-fixed assets.

Gary Kellermann, the park's last director of maintenance and safety, leans up against a game building on the last day Santa's Village was open on September 18, 2005. Kellerman wondered if all the speculations that had been circulating would come true.

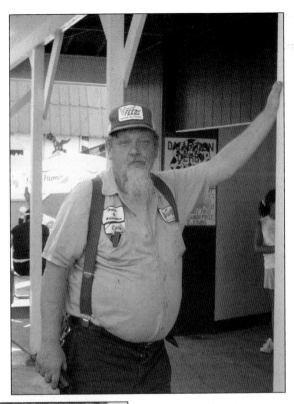

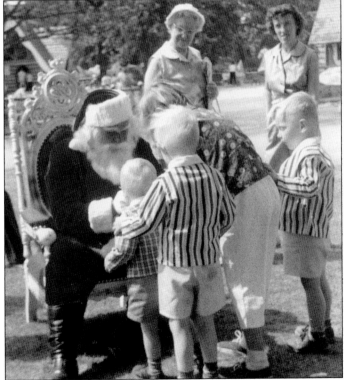

Kellermann was no stranger to Santa's Village. In this 1959 photograph, he and his family visit the original Santa, Jim Combs. Kellerman is the little boy to the far right of the picture.

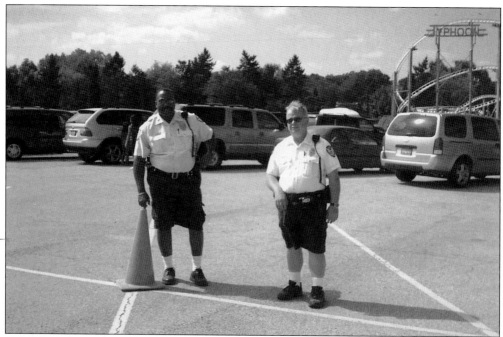

A good-sized crowd visited Santa's Village on what would be the last day of operations. Security was aware that park visitors might be looking for a little more than the normal souvenirs. Here security guard Al Womack (left) and Capt. Dean Stamm prepare for the upcoming day.

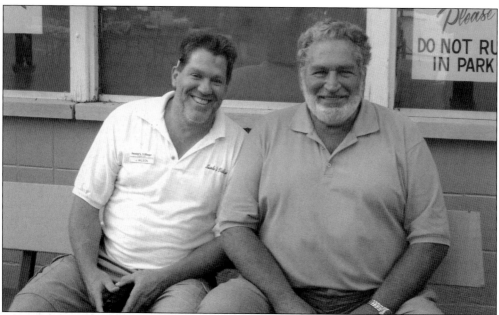

Jeff Wilson and his father, Hugh, sit on a bench near the entrance to Santa's Village on the last day. The Wilson family owned Santa's Village, the Polar Dome Ice Arena, and Racing Rapids for 28 of the 46 years. Hugh, along with his late business partner, Philip Oestreich, founded the North Pole Corporation that bought the assets from the Medina Investors in 1978. Over the years, most members of the Wilson and Oestreich families worked at the park.

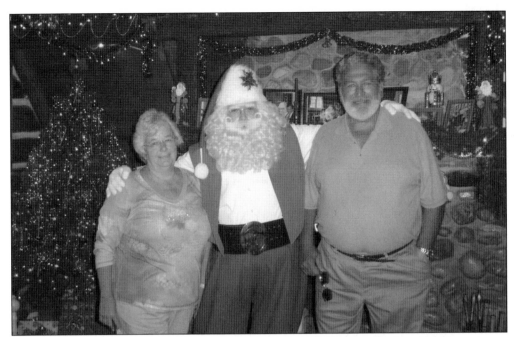

Mary Wilson and her husband, Hugh, stopped in Santa's House on the last day. It was a very moving day for the entire Santa's Village family. The Wilsons had the hope of retirement on their minds and this was going to be their last time in the park while it was open. If Santa's Village was to open again, it would be with new owners.

Tom Pool came on board in 2006 and became a valuable asset in controlling the difficulties surrounding Santa's Village. Pool spent nearly every day at the park for seven months answering questions from curious visitors and running security. In June 2006, land owner Sterling Bay Companies of Chicago and North Pole Corporation asked Phillip L. Wenz to become the acting administrator for Santa's Village and he accepted. It was a lot more work than one man could handle, so Pool stepped in to assist him.

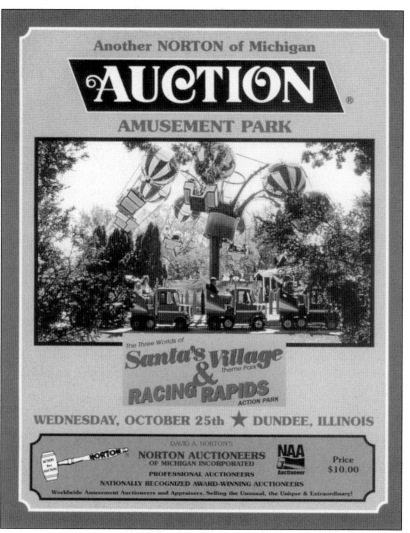

Another NORTON of Michigan

AUCTION

AMUSEMENT PARK

The Three Worlds of
Santa's Village Theme Park
&
RACING RAPIDS ACTION PARK

WEDNESDAY, OCTOBER 25th ★ DUNDEE, ILLINOIS

DAVID A. NORTON'S
NORTON AUCTIONEERS
OF MICHIGAN INCORPORATED
PROFESSIONAL AUCTIONEERS
NATIONALLY RECOGNIZED AWARD-WINNING AUCTIONEERS
Worldwide Amusement Auctioneers and Appraisers. Selling the Unusual, the Unique & Extraordinary!

NAA
Auctioneer

Price
$10.00

With the auction drawing closer each day, Phillip L. Wenz, acting Santa's Village park administrator, released the following statement in September 2006: "The ongoing developments at Santa's Village are a growing concern to the park's loyal following and the East Dundee community. To my knowledge an agreement between North Pole Corporation and North Pole Village, L.L.C. (a group of East Dundee businessmen) was entered and started in February 2006. This agreement went into default as funding was not secure on May 31, 2006. . . . An October 25, 2006 asset auction is planned by North Pole Corporation. Sterling Bay retains all rights to the land and the fixed assets. Personal assets and awarded assets are not in play. Today Santa's Village stands on the corners of State Routes 25 and 72 empty of the children's screams of laughter. Rides are motionless, the North Pole melted, and no summertime visits with Santa. The refurbishment work has been put on hold. An eerie silence cascades throughout the park. It is very unfortunate that this situation has happened. Promises have been broken. All of the family outings, picnics, and group trips had to be canceled. Employees, vendors, entertainers, and contractors have been laid off. Numerous contracts and payrolls have not been honored. It is truly sad. The future of Santa's Village is now, at best, speculative. There is an understanding between all three parties that this situation at Santa's Village needs a timely resolution. There are no guarantees. At this point in time Santa's Village is closed to the public."

For the first time in 46 years, the North Pole at Santa's Village stands empty of its icy covering.

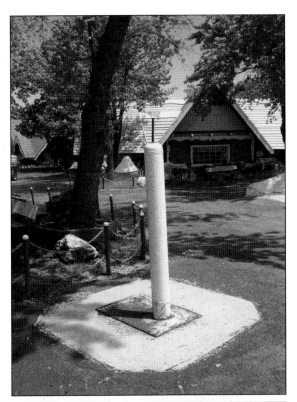

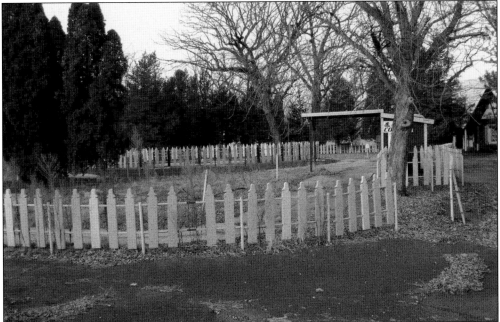

By the end of 2006, the rides, games, and non-fixed assets had been removed. This is the original location where the whirling Christmas Tree Ride once stood. In 1992, the ride was replaced with the Balloon Race. The track that surrounds the empty pad was the original location for the Pony Carts, which were replaced by the Convoy Trucks.

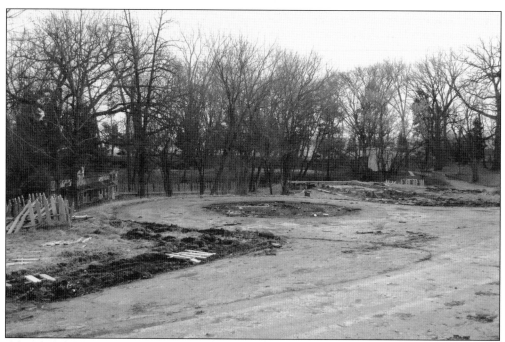

After the auction in October 2006, the Santa's Village rides were dismantled and taken to their new homes all across the country. This is where the YO-YO swings and the Galleon Pirate Ship once entertained thousands.

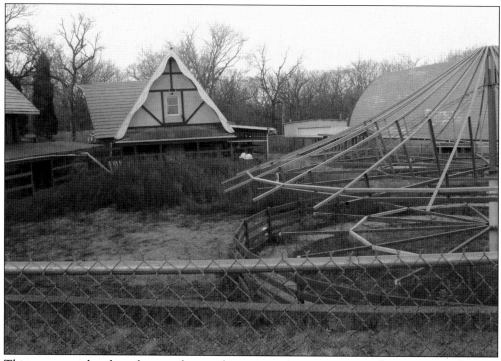

This empty and unkept barnyard was where goats, ponies, cows, and exotic animals once called home.

The pad where the North Pole once stood now stands in the middle of an empty park.

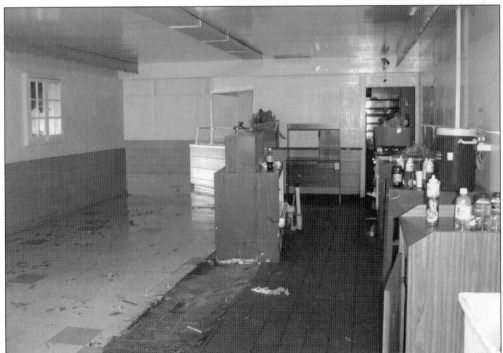

The Ice Cream Parlor stands nearly cleaned out. This building was originally Mrs. Claus's Candy Kitchen.

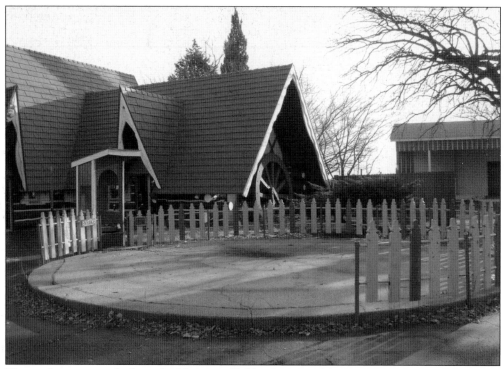

Here is the empty pad where the Hampton Kiddie Cars stood for over 30 years.

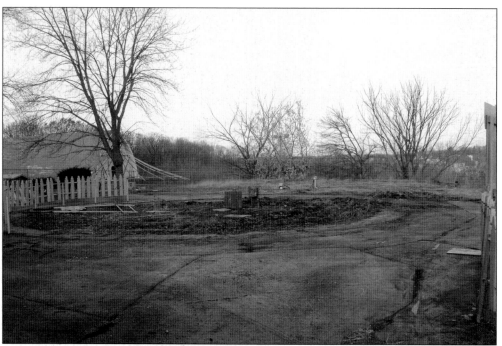

This area was once home to the merry-go-round and the Dracor the Dragon Coaster. Other rides that stood in this area were the gasoline-powered tractors, the Candy Cane Coaster, and the Cannon Ball Roller Coaster.

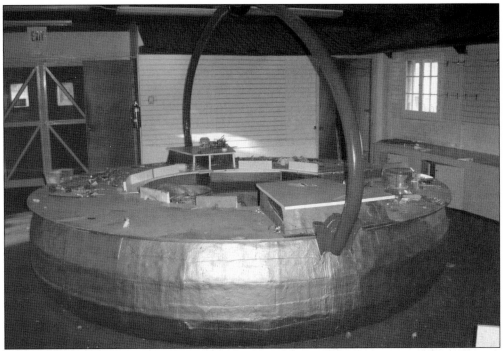

Inside Santa's main souvenirs building is the giant melting pot that was once a cash-out station.

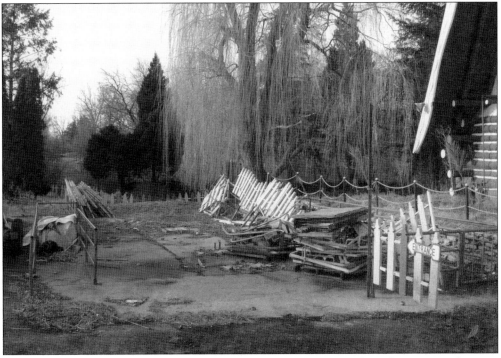

This is the landing for the Skyliner lift chairs. Notice that even the tall towers in the trees are gone.

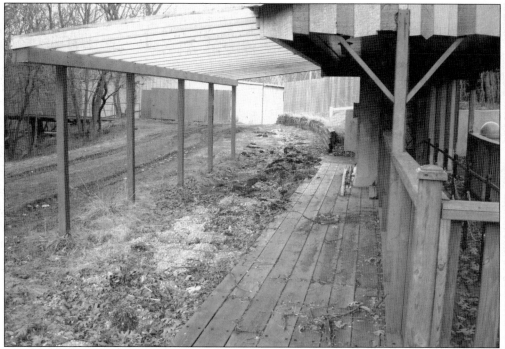

Here is the Santa's Village Train Station. Over the years, the park had four different trains: a locomotive, a C. P. Huntington, a Santa Fe, and a switch engine painted like an Amtrack train.

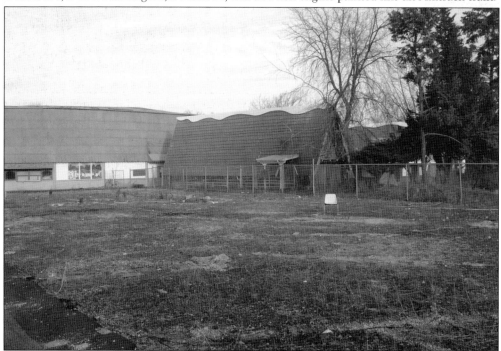

This is where the Pumpkin Coach originally turned to load. After the length of the Pumpkin Coach track was shortened, the Galaxi Roller Coaster and later the Typhoon Roller Coaster sat in this area.

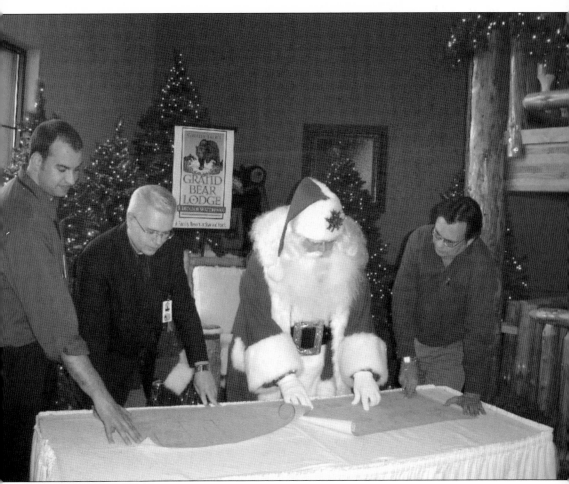

Officials at the Grand Bear Lodge in Utica meet with Santa to discuss the possibility of opening a new version of Santa's Village. This new version would have some of the original rides and props of the Dundee park. Grand Bear Lodge owner Joe Hook (far right) bought the Snowball Ride and the Great Wheel, among other things, in October 2006. Landowner Sterling Bay Companies of Chicago is still keeping all options open on the land as well. The infrastructure of the park still exists.

Across America, People are Discovering Something Wonderful. Their Heritage.

Arcadia Publishing is the leading local history publisher in the United States. With more than 3,000 titles in print and hundreds of new titles released every year, Arcadia has extensive specialized experience chronicling the history of communities and celebrating America's hidden stories, bringing to life the people, places, and events from the past. To discover the history of other communities across the nation, please visit:

www.arcadiapublishing.com

Customized search tools allow you to find regional history books about the town where you grew up, the cities where your friends and family live, the town where your parents met, or even that retirement spot you've been dreaming about.